Children's Portrait
PHOTOGRAPHY HANDBOOK

Techniques for Digital Photographers

Bill Hurter

AMHERST MEDIA, INC. ■ BUFFALO, NY

ABOUT THE AUTHOR

Bill Hurter started out in photography in 1972 in Washington, DC, where he was a news photographer. He even covered the political scene—including the Watergate hearings. After graduating with a BA in literature from American University in 1972, he completed training at the Brooks Institute of Photography in 1975. Going on to work at *Petersen's PhotoGraphic* magazine, he held practically every job except art director. He has been the owner of his own creative agency, shot stock, and worked assignments (including a year or so with the L.A. Dodgers). He has been directly involved in photography for the last thirty years and has seen the revolution in technology. In 1988, Bill was awarded an honorary Masters of Science degree from the Brooks Institute. In 2007 he was awarded an honorary Masters of Fine Arts degree from Brooks. He is also a member of Brooks' board of trustees. He has written more than thirty instructional books for professional photographers and is currently the editor of *Rangefinder* and *AfterCapture* magazines.

Front cover photograph by Ruzz.
Back cover photograph by Nichole Van Valkenburgh.

Published by:
Amherst Media, Inc.
P.O. Box 586
Buffalo, N.Y. 14226
Fax: 716-874-4508
www.AmherstMedia.com

Publisher: Craig Alesse
Senior Editor/Production Manager: Michelle Perkins
Assistant Editor: Barbara A. Lynch-Johnt
Editorial Assistance from: Sally Jarzab, John S. Loder, Charles Schweizer

ISBN-13: 978-1-58428-996-8
Library of Congress Control Number: 2009911200
Printed in Korea.
10 9 8 7 6 5 4 3 2 1

Check out Amherst Media's blogs at: http://portrait-photographer.blogspot.com/
http://weddingphotographer-amherstmedia.blogspot.com/

TABLE OF CONTENTS

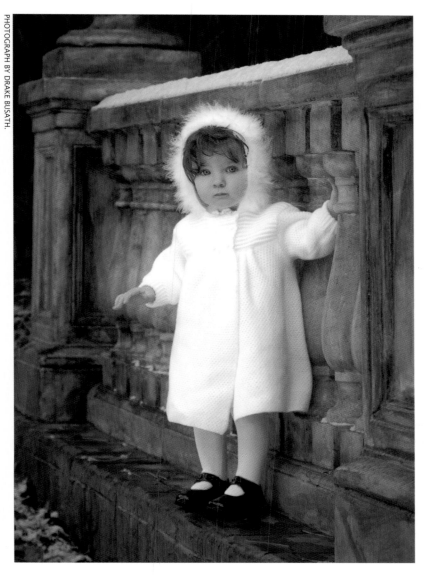

PHOTOGRAPH BY DRAKE BUSATH.

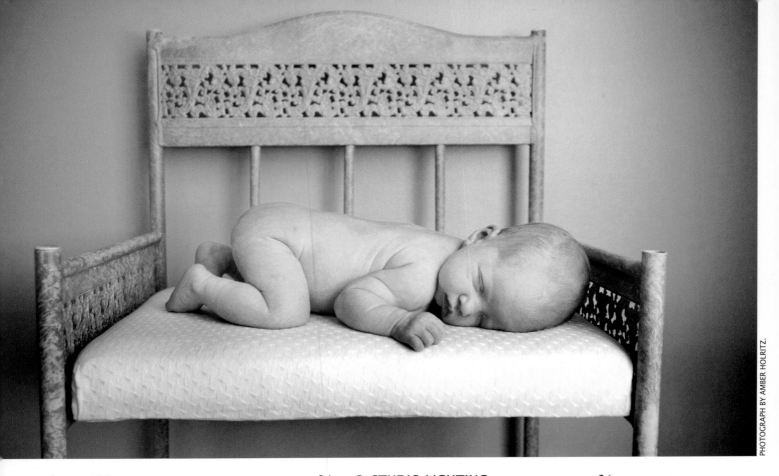

PHOTOGRAPH BY AMBER HOLRITZ.

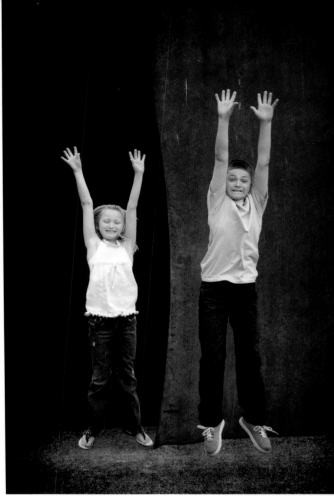

PHOTOGRAPH BY JIM GARNER.

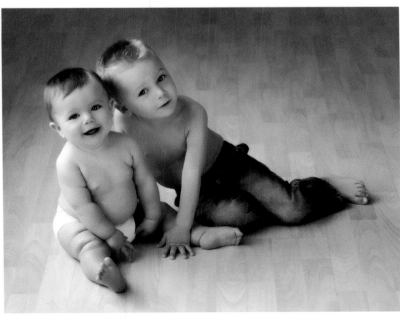

PHOTOGRAPH BY VICKI TAUFER.

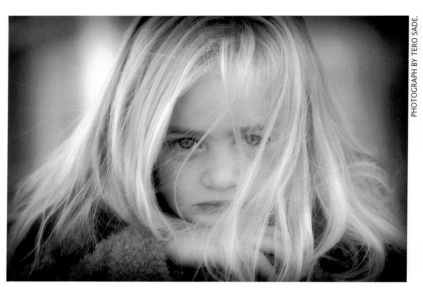

PHOTOGRAPH BY TERO SADE.

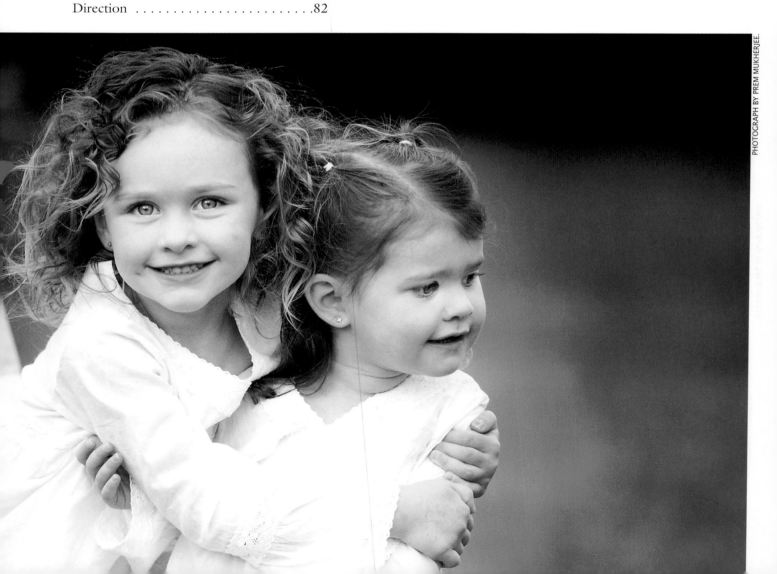

PHOTOGRAPH BY PREM MUKHERJEE.

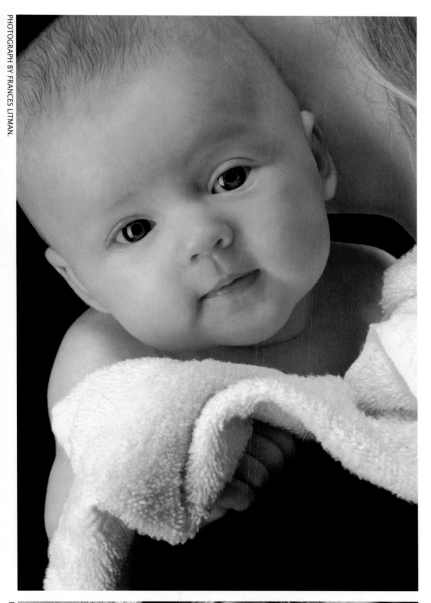

PHOTOGRAPH BY FRANCES LITMAN.

PHOTOGRAPH BY TIM SCHOOLER.

INTRODUCTION

Working with babies, small children, and teenagers can be a frustrating experience for any professional photographer. Kids are unpredictable. Things can be going along well during a session when, for no apparent reason, the mood changes and you are suddenly dealing with an uncooperative or (in the worst case scenario) screaming, out-of-control subject.

It doesn't seem to matter what personality type you are as a photographer, kids are either generally responsive to you or they aren't—and predicting which way it will go can be difficult. For example, I know a photographer who tends to be gruff and grumpy most of the time. One reasons, "If he's this bad with adults, how can children tolerate him?" But, at least in this case, children seem to love this otherwise grumpy Gus and are completely at ease in front of his camera.

THE CHALLENGES

Even if you do everything perfectly, producing beautiful posing and lighting, animated ex-

Here, two pals are having an animated conversation while running as fast as they can—something only children could achieve. Suzette Nesire, with the reflexes of a top sports photographer, captured them at the apex of their reverie.

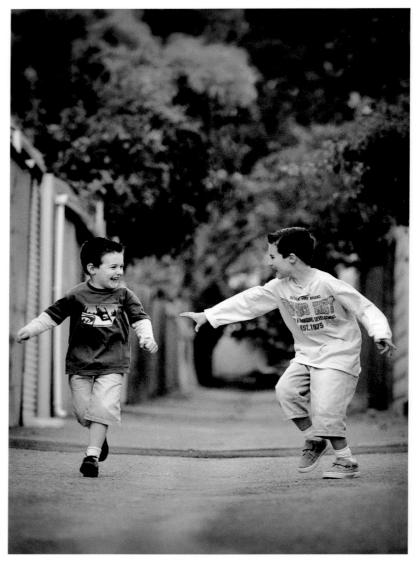

When you're a children's portrait specialist, your studio is packed with miniature props, like this tiny antique love seat, and colorful backgrounds. This priceless portrait is by Alycia Alvarez.

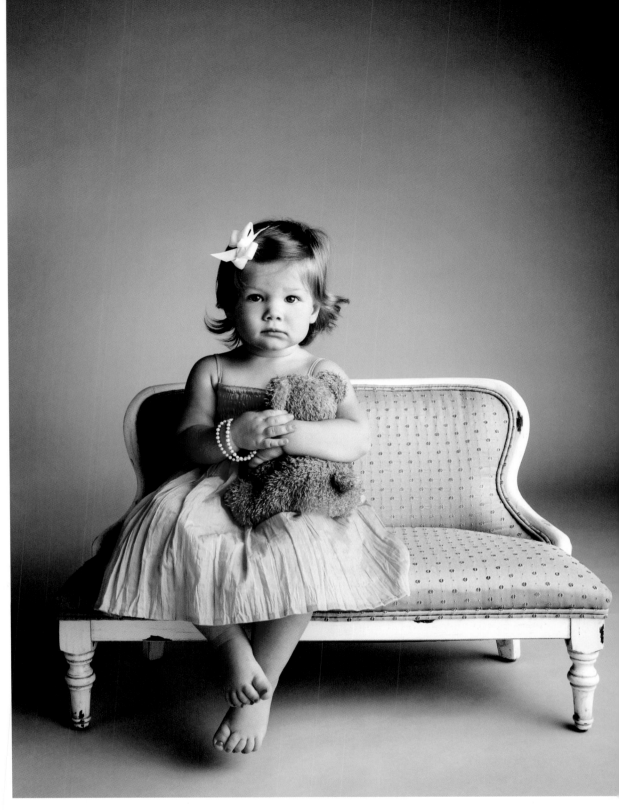

pressions, and a wide selection of images, the parents might say something like, "Wow, that just doesn't look like our little boy." That's because parents form idealized mental images of their kids. As a result, when they see them in pictures, they sometimes don't emotionally relate to the child in the photograph. What they see in their mind's eye is their perfect child, not necessarily the same child who was just photographed.

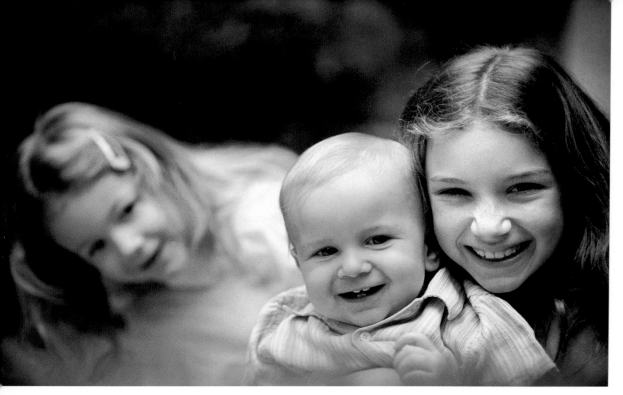

Photographing kids of all ages is a very special skill. Photographers like Suzette Nesire have a great knack for working with and capturing children's innermost worlds of fun. Here, she photographed two sisters with their new baby brother— a newcomer with whom they are especially delighted.

While adults can control their environment, children cannot. As a result, kids (especially little ones) are often easily frightened. Therefore, extra care must be taken to provide a safe and fun working environment. The photographic experience must, in and of itself, be enjoyable for the child. Keep in mind that, as adults, our senses have been bombarded for years. To children, on the other hand, every sensation is new and unexpected. Because children's communication skills are also limited, they react much more expressively than adults; young children cannot hold back an expression or reaction to a new experience. These expressions are what define a child's personality—and knowing how to extract them is the key to getting great children's photos.

THE REWARDS

George Eastman, the great-grandfather of the Eastman Kodak Company, once said that there are about 160 things that can go wrong in the taking of a picture. Clearly, he wasn't talking about child's portraiture—because there are easily double that number of things that can go wrong in the typical child's sitting.

But if children's portraiture were completely impossible, then there wouldn't be so many children's photographers in the world. There are many rewards for excelling at this special skill. One successful children's photographer says that photographing children gives him an opportunity to be a kid himself, almost as if the process were an extension of his not yet

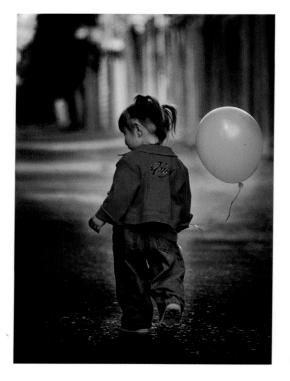

What parent wouldn't want a priceless image like this of their daughter? Photograph by Suzette Nesire.

being grown up. There is no doubt that the opportunity to enjoy the innocence of children—over and over again—is appealing.

Australian photographer Suzette Nesire, who is extremely well regarded at home and now abroad, says about her work on her website, "I remember years ago Mum saying you don't own your children, they're only on loan. As a photographer, I feel there is nothing more important than capturing your little ones and their early years—their faces, their expressions, their little hands, and their habits that constantly change. A portrait of your young child is a priceless reminder of a time that once passed and will never return again. Choose to make an investment in a portrait of your child, as pictures convey so much more than words can ever express."

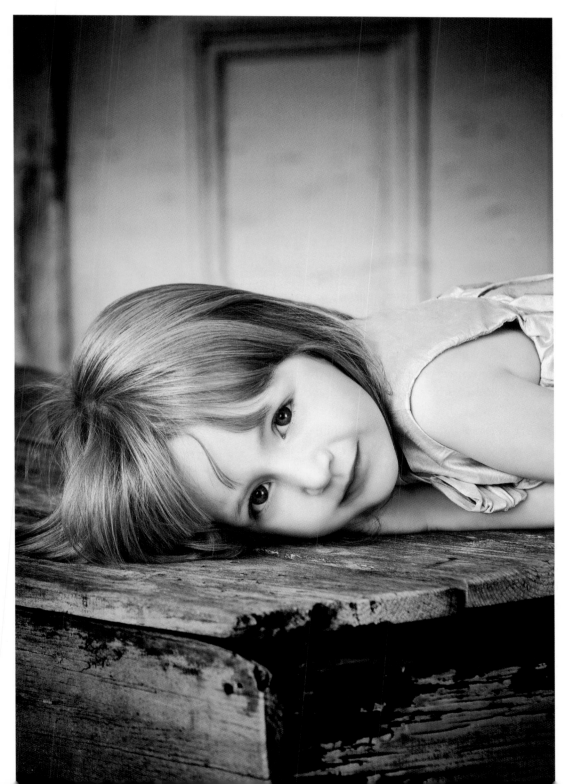

Portraits like this are works of art that transcend parents' historical records of a child's growth. This image conveys universal truths about a child's innate innocence and beauty; it represents the quality of work all children's portrait photographers aspire to create. Photograph by Anthony Cava.

Most of today's finest children's portrait photographers use 35mm-format digital SLRs (DSLRs). Medium and large formats, once mainstays of the industry, have almost entirely gone out of use due to the popularity and flexibility of the DSLR.

LENSES

The rule of thumb for selecting an adequate portrait focal length is to choose one that is twice the diagonal of the format you are using. For instance, when using a camera with a full-frame image sensor (equal to a 35mm film frame), a 75 to 85mm lens is usually a good choice.

With sensors smaller than 24x36mm, all lenses get effectively longer in focal length. This is not usually a problem where telephotos and telephoto zooms are concerned, since the maximum aperture of the lens doesn't change, but when your expensive wide-angles or wide-angle zooms become significantly less wide

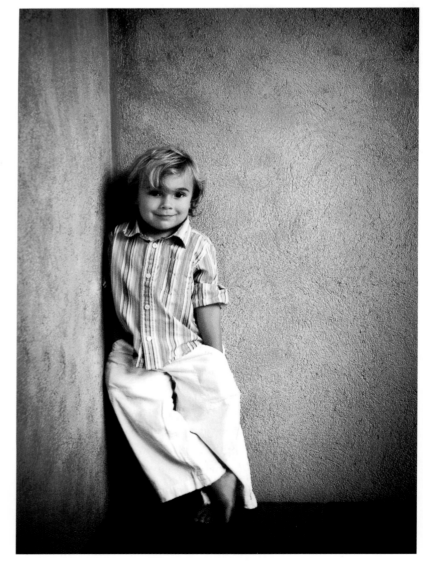

A 50mm lens is an ideal focal length to use for a three-quarter- or full-length portrait. It provides a good working distance and incorporates the background nicely into the photo. Here, the photographer wanted the stucco wall to be rendered sharply, so he used an EF 50mm f/2.5 Compact Macro lens at f/11 on a Canon EOS 5D camera. Photograph by Anthony Cava.

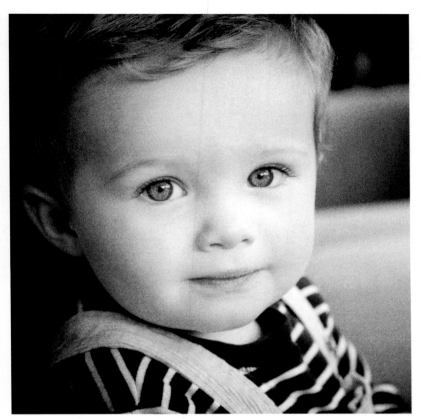

A short telephoto, here a 70mm setting on a 24–70mm zoom, provides good perspective, a large image size, and a good working distance for photographing children. Photograph by Jo Gram of Flax Studios in New Zealand. Image made with Canon EOS 1D Mark II.

on the digital camera body, it can be somewhat frustrating. For example, with a 1.5x lens focal length factor, a 17mm lens becomes a 25mm lens.

Fortunately, the camera manufacturers that have committed to smaller chip sizes have started to introduce lens lines specifically designed for digital imaging. With these lenses, the circle of coverage (the area of focused light falling on the film plane or digital-imaging chip) is smaller and more collimated to compensate for the smaller chip size. Thus, the lenses can be made more economically and smaller in size, yet still offer as wide a range of focal lengths as traditional lenses.

The Normal Lens. When making three-quarter- or full-length portraits, it is advisable to use the normal focal-length lens (35mm to 50mm, depending on the camera's sensor size, as noted above). Because of a child's size,

a three-quarter- or full-length portrait of a child requires that you work much closer to the subject than you would for an adult's portrait. This "normal" lens will provide an undistorted perspective when working at these distances.

The only problem you may encounter with a normal lens is that the subject may not separate visually from the background. It is usually desirable to have the background slightly out of focus so that the viewer's attention goes to the child, rather than to the background. With normal and shorter focal-length lenses, depth of field is slightly increased. As a result, even when working at wide lens apertures, it may be difficult to separate the subject from the background. This is particularly true when working outdoors, where patches of sunlight or other distracting background elements can easily draw your eye away from the subject. (*Note:* Fortunately, in the digital age, it is a fairly simple task to diffuse background elements later in post-processing.)

The Short Telephoto. In adult portraiture, shooting with a short telephoto lens helps you maintain accurate perspective. Since children are much smaller than adults, a short telephoto has the same effect as a longer telephoto lens in adult portraiture. A short telephoto can, however, provide a greater working distance, which can be useful when photographing children. It will also soften the background due to its inherently reduced depth of field.

Longer Telephotos. You can use a much longer lens if you have the working room. A 200mm lens or the very popular 80–200mm f/2.8 zoom (manufactured by both Nikon and Canon), for instance, is a beautiful portrait lens because it provides very shallow depth of field and allows the background to fall completely out of focus, providing a backdrop that won't distract from the subject. Such lenses also provide a very narrow angle of view. When used at large apertures, this

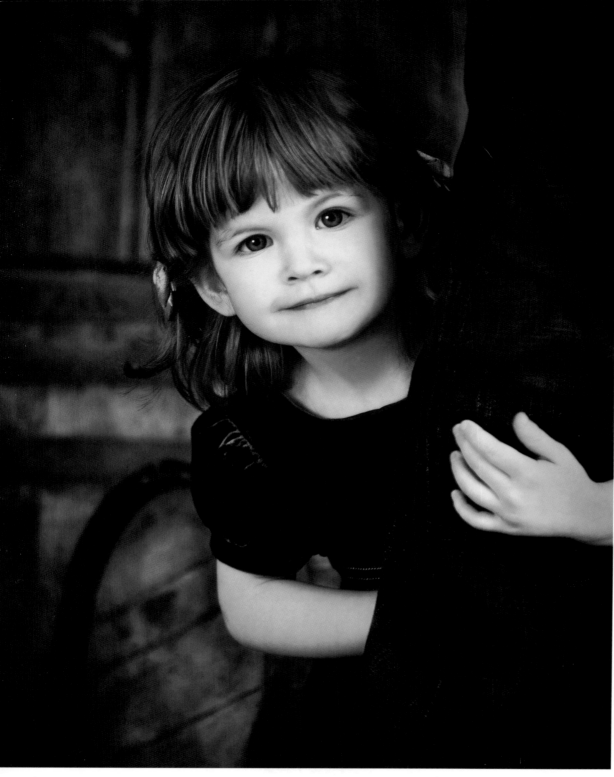

An effective focal length of 300mm (an 80–200mm zoom used on a Nikon D2X) provided tight cropping and a shallow depth of field, minimizing the background. The exposure was made at $^1/_{100}$ second at f/3.5 by Anthony Cava.

focal length provides a very shallow band of focus that can be used to accentuate just the eyes, for instance, or just the frontal planes of the child's face. The flexibility of the 80–200mm zoom allows you to vary the focal length to intermediate settings, like 105mm or 120mm, so that you can achieve correct perspective as well as good background control and composition.

In most cases, you should avoid using extreme telephotos longer than 300mm. First, the perspective becomes distorted and features start to appear compressed. Depending on the working distance, the nose often looks pasted

onto the child's face and the ears of the subject appear parallel to the eyes. Secondly, you must work far away from the child with such a lens, making communication next to impossible. You want to be close enough that you can converse normally with the child. There will be times, however, when your close presence is annoying to the child. In these cases, an assistant may play the role of "good cop," while the long telephoto removes you from the immediate situation.

FOCUSING

Focal Point. In a head-and-shoulders portrait, it is important that the eyes and frontal planes of the face be tack sharp. When working at wide lens apertures where depth of field is reduced, you must focus carefully to hold the eyes, ears, and tip of the nose in focus. This is where a good knowledge of your lenses comes in handy. Some lenses have the majority of their depth of field behind the point of focus; others have the majority of their depth of field in front of the point of focus. You need to know how your different lenses focus. Additionally, it is important to check the depth of field with the lens stopped down to your taking aperture, using your camera's depth-of-field preview control.

Your main focal point should always be the eyes, which will also keep the lips (another frontal plane of the face) in focus. The eyes are the region of greatest contrast in the face. This makes focusing simple—particularly for autofocus cameras that require areas of contrast on which to focus.

When the subject's face turned so that it is at an angle to the camera, the eyes are not parallel to the image plane. In this case, you may have to split focus on the bridge of the nose to keep both eyes sharp—particularly at wide lens apertures.

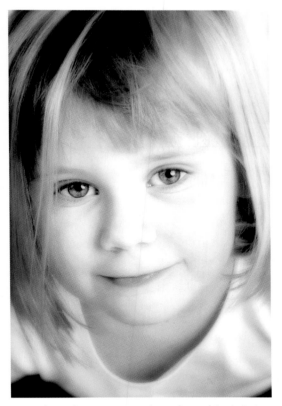

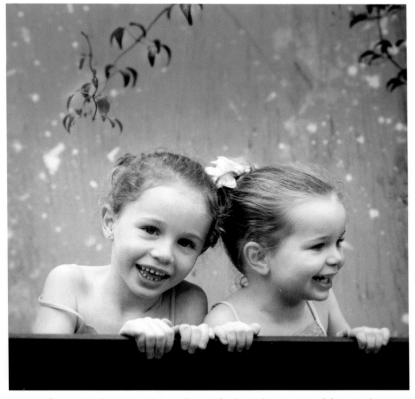

LEFT—In a close-up portrait such as this, it is imperative to focus on the eyes. Regardless of what else is out of focus, the eyes must be sharp. Photograph by Marcus Bell. **RIGHT**—It's a good habit to try to an align hands and faces in the same plane so that both regions can be rendered sharply. Here, careful control of the plane of focus allowed the photographer to keep hands and face sharp, but the background is pleasingly blurred. Photograph by Suzette Nesire.

Properly focusing three-quarter or full-length portraits is generally easier because you are farther from the subject, where the depth of field is greater. Again, you should split your focus halfway between the closest and farthest points that you want to be sharp in the image. With these portraits, it is still a good idea to work at wide lens apertures to keep your backgrounds soft.

Autofocus. Autofocus, which was once unreliable and unpredictable, is now extremely advanced. Some cameras feature multiple-area autofocus so that you can, with just a touch of a thumbwheel, change the active AF sensor area to different areas of the viewfinder (the center or outer quadrants). This allows you to "de-center" your images for more dynamic compositions.

Autofocus and moving subjects used to be an almost insurmountable problem. While you could predict the rate of movement and focus accordingly, the earliest AF systems could not. Now, however, almost all AF systems use a form of predictive autofocus, meaning that the system senses the speed and direction of the movement of the main subject and reacts by tracking the focus of the moving subject. This is an ideal feature for activity-based portraits, where the subject's movements can be highly unpredictable.

A new addition to autofocus technology is dense multi-sensor area AF, in which an array of AF sensor zones are densely packed within the image frame, making the process of precision focusing much faster and more accurate. These AF zones are user-selectable or can all be activated at the same time for the fastest AF operation.

Image Stabilization. Image-stabilization lenses optomechanically correct for camera movement and allow you to shoot handheld with long lenses and relatively slow shutter speeds. Canon and Nikon, two companies that currently offer this feature in their lenses, offer a wide variety of zooms and long focal-

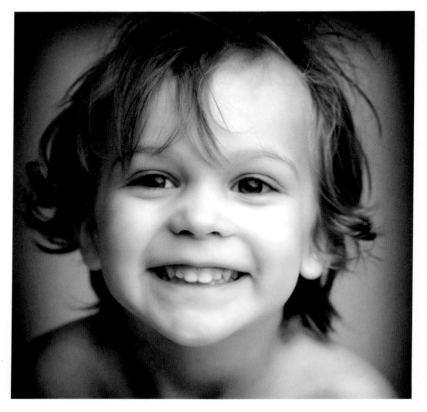

length lenses with image stabilization. With this feature, when using a zoom with a maximum aperture of f/4, you can still shoot handheld wide open in subdued light at $\frac{1}{10}$ or $\frac{1}{15}$ second and get dramatically sharp results. You can also use the light longer in the day and still shoot with higher-quality ISO 100 and 400 speed settings.

APERTURE

Depth of Field. Telephoto lenses have less depth of field than shorter lenses. This is why so much attention is paid to focusing telephotos accurately. The closer you are to your subject, the less depth of field you will have. When you are shooting a tight face shot, be sure that you have enough depth of field at

With fast-moving children and their level of unpredictability, photographers rely on ultra-fast, extremely accurate autofocusing systems. Multi-point AF with predictive autofocus is a part of the top professional cameras like the Canon EOS 1D Mark II used here. Photograph by Jim Garner.

When using a normal lens and a camera-to-subject distance that creates a full-length portrait, it is fairly easy to capture the full subject in focus with a relatively wide aperture like f/4 or f/5.6. This elegant studio portrait was made by Brian Shindle.

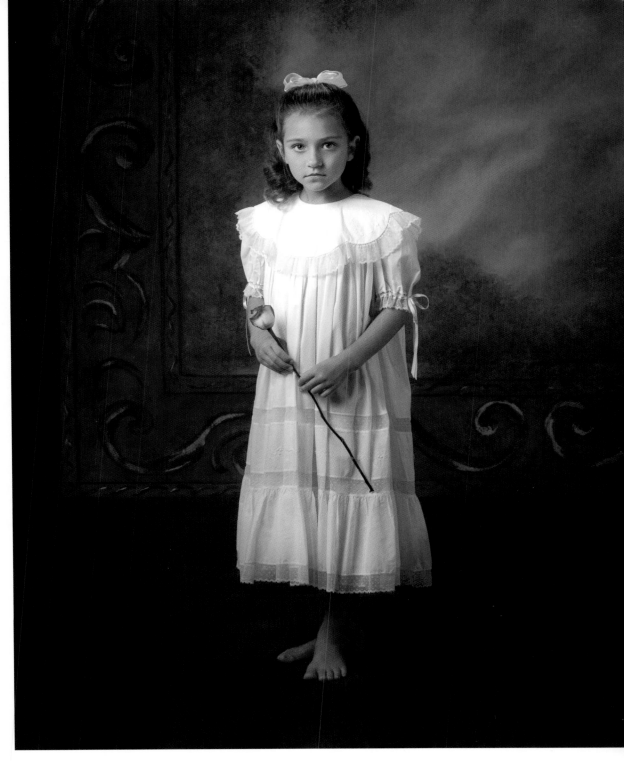

your working aperture to hold the focus on the important planes of the face.

Shooting Aperture. Choosing the working lens aperture is traditionally a function of exposure level, but it is a matter of preference in many cases. For example, some photographers prefer f/8 to f/11, even though f/11 affords quite a bit more depth of field than f/8. This is often because of the relationship between the subject and the background at various working distances.

Many photographers strongly prefer certain lens apertures. Some will shoot wide open, even though many lenses—even expensive ones—suffer from spherical aberration at their widest apertures. The wide-aperture prefer-

ence arises from a desire to create a very delicate plane of focus, making the point of focus the focal point of the composition.

Other photographers, often traditionalists accustomed to the focus-holding swing and tilt movements of large format cameras, will opt for a small taking aperture that holds every plane of the subject in focus. This preference is most often seen in the studio, where background distance can be controlled, thus limiting the sharpness only to the subject.

There are those, too, who will shoot at the same aperture most of the time. Why, when there is almost infinite variability, would one choose the same aperture every time? Because these photographers know that aperture inside and out and can predict the final results—both the region of focus and depth of field—at almost any working distance. It is the predictability that they like.

Optimum Aperture. It is said that the optimum aperture of any lens is $1\frac{1}{2}$ to 2 stops from wide open. This optimum aperture corrects spherical and some chromatic aberrations experienced when the lens is used wide open.

SHUTTER SPEEDS
Your shutter speed must eliminate both camera and subject movement. If you are using available light and a tripod, a setting of $\frac{1}{30}$ to $\frac{1}{60}$ second should be adequate to stop average subject movement (the tripod eliminates camera movement).

Outdoors. When working outdoors, you should generally choose a shutter speed faster than $\frac{1}{30}$ second because slight breezes will cause the subject's hair to flutter, producing motion during the moment of exposure.

Handholding. If you are handholding the camera, the general rule of thumb is to select a shutter speed setting that is the reciprocal of the focal length of the lens. For example, if using a 100mm lens, use $\frac{1}{100}$ second (or the next highest equivalent shutter speed, like $\frac{1}{125}$ second) under average conditions. If you are

very close to the subject, as you might be when making a head-and-shoulders portrait, you will need to use a faster shutter speed (higher image magnification requires this). When farther away from the subject, you can revert to the reciprocal shutter speed.

Moving Subjects. When shooting moving children, use a faster shutter speed and a wider lens aperture. It's more important to freeze your subject's movement than it is to have great depth of field for this kind of photo. If

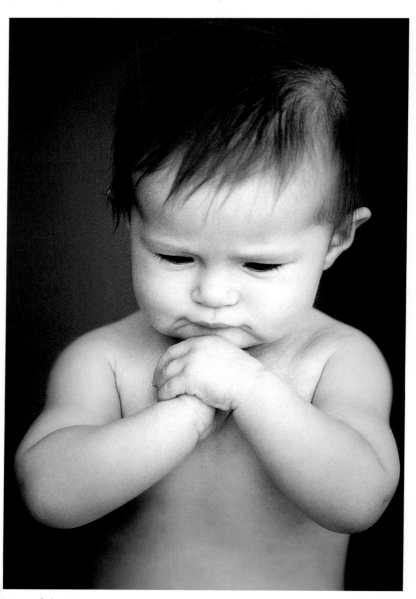

Most of the time, you will be concentrating hard on the child's expression, looking for that elusive fleeting moment to fire the shutter. Good technical habits free you to concentrate completely on the moment. Photograph by Suzette Nesire.

Photographers brought up working on studio cameras will often opt for a smaller taking aperture. Here, Deborah Lynn Ferro used an exposure of $^{1}/_{60}$ second at f/8 to maintain sharpness throughout the little girl and her outfit. The background and clothing are from Deborah's own clothing line for children (www.ferrophoto props.com).

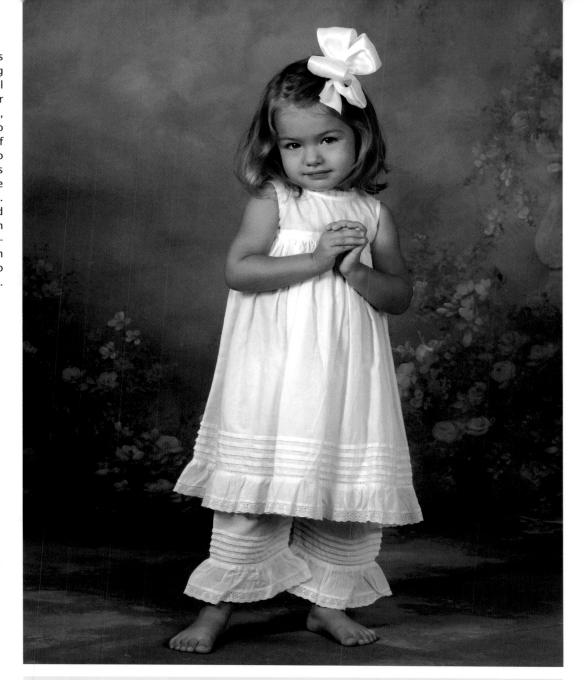

The Popularity of Fast Zoom Lenses

With the advent of smaller image sensors, lens and camera manufacturers have the ability to more affordably design and manufacture faster lenses. The preferred f-stop seems to be f/2.8. At apertures slower (smaller) than that, photographers complain the viewfinder is too dim. At apertures faster (bigger) than that, the lens is prohibitively expensive to make in the zoom models—thus the overwhelming popularity of the 70–200 and 80–200mm f/2.8 zoom lenses. Both Canon and Nikon make these focal lengths—and while they are still on the pricey side, they really perform. Both series of lenses use internal focusing, so the length of the lens does not change in focusing/zooming. Internal focusing also drastically enhances autofocusing speed. These lenses use rare-earth lens elements in the design and can employ state-of-the-art technology, including vibration reduction.

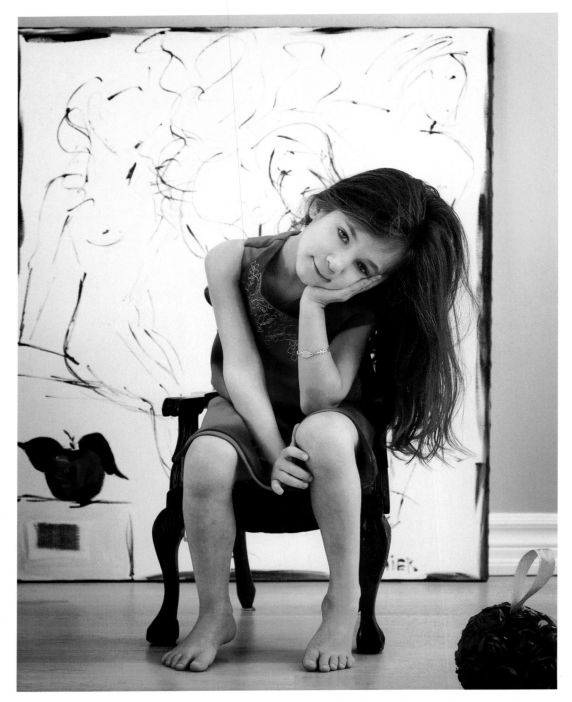

LEFT—The 80–200mm f/2.8 zoom is an ideal lens to use when making children's portraits; it provides both great cropping versatility and lens speed. Here, Anthony Cava made a portrait of his daughter Francesca with an 80–200mm zoom at $^1/_{60}$ second at f/3.2, close to the optimum aperture of the lens.

FACING PAGE—Stopping moving subjects, like these high-flying siblings, takes a fast shutter speed and knowledge of how to photograph peak-action photos. Photograph by Jim Garner. The exposure was made at $^1/_{400}$ second at f/5.6 with a Canon EOS 1D Mark II and EF 70–200mm f/2.8L IS USM lens.

you have any doubts about the right speed to use, always use the next fastest speed to ensure sharper images.

With Flash. If you are using electronic flash and a camera with a focal-plane shutter, you are locked into the X-sync speed your camera calls for. With focal plane shutters, you can always use flash and a slower-than-X-sync shutter speed, a technique known as "drag-ging the shutter," meaning to work at a slower-than-flash-sync speed to bring up the level of the ambient light. This effectively creates a flash exposure that is balanced with the ambient-light exposure.

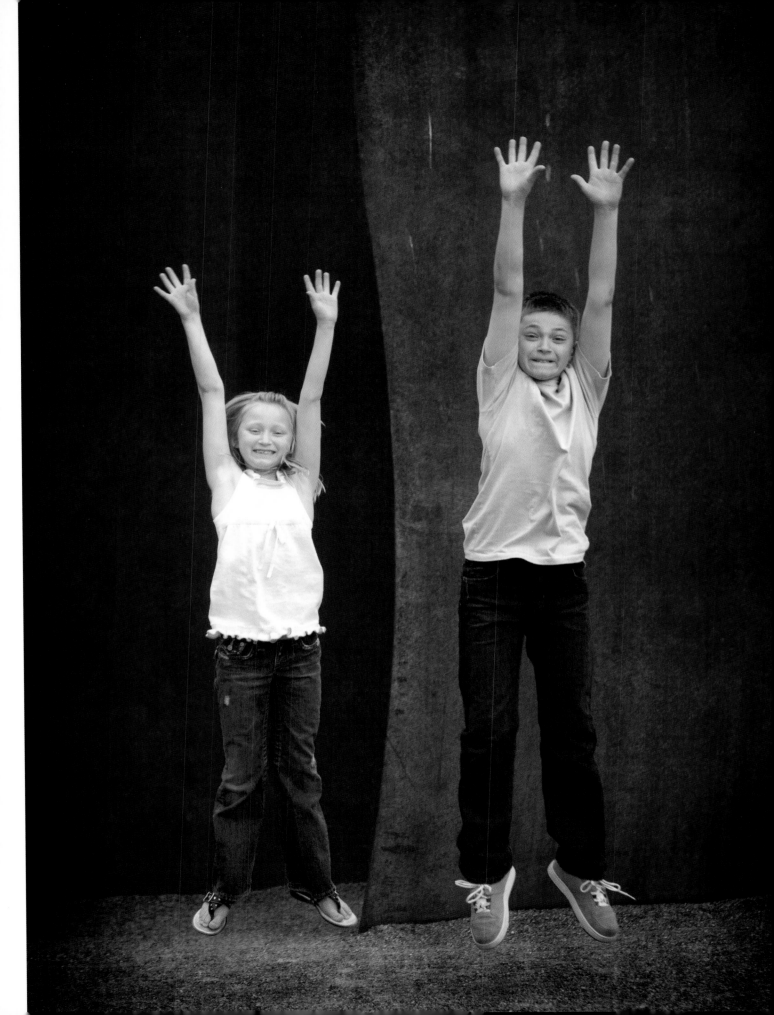

2. DIGITAL CONSIDERATIONS

Perhaps the greatest advantage of shooting digitally is that you leave the event or session with images in hand. Instead of scanning the images when they are returned from the lab, the originals are already digital and ready to be brought into Photoshop for retouching or special effects and subsequent proofing and printing. The instantaneous nature of digital even allows photographers to put together a digital slide show almost immediately. Additionally, digital offers photographers great options when shooting—from frame to frame, you can switch your ISO and white balance, or even switch to shooting in black & white. In this chapter, we'll look at these considerations and many others.

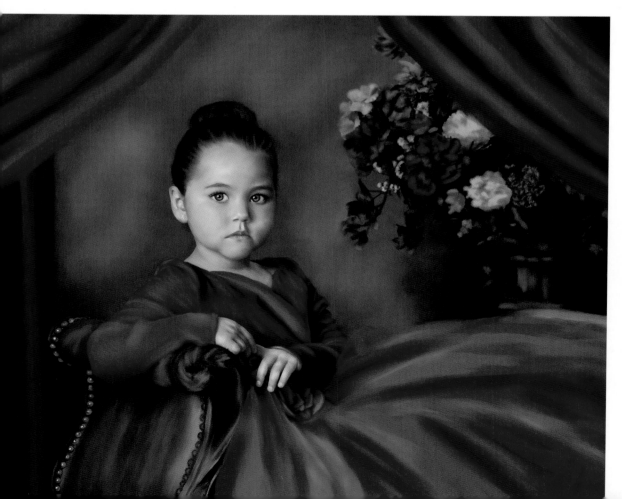

The digital environment allows the photographer complete artistic freedom. This classically lit and posed children's portrait by Deborah Lynn Ferro was rendered a lovely painting in Corel Painter, a software program designed to reproduce literally any type of artist's brush stroke.

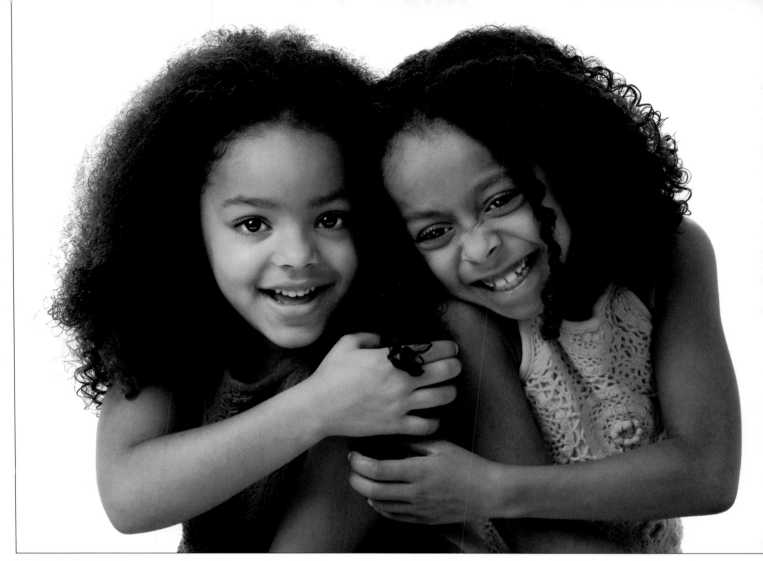

Sophisticated digital camera systems let you review the histogram (a graph that indicates the number of pixels that exist for each brightness level in an image) and highlight point to determine if your exposure is perfect—as it is here. Photograph by Deborah Lynn Ferro.

LCD PLAYBACK

The size and resolution of the camera's LCD screen are important, as these screens are highly useful in determining if you got the shot or not. LCD screens range from about 1.8 inches to 2.5 inches and screen resolution ranges from around 120,000 dots to 220,000 dots. As important as the physical specifications of the LCD is the number of playback options available. Some systems let you zoom in on the image to inspect details. Some let you navigate across the image to check different areas of the frame in close-up mode. Some camera systems allow you a thumbnail or proof-sheet review of captured images. Some of the more sophisticated systems offer his-togram (to gauge exposure) and highlight-point displays to determine if highlight exposure is accurate throughout the image. Both features are highly useful, especially when specific detail is needed in the final image, like the highlight detail of a white christening dress.

BATTERY POWER

Although you don't need motorized film transport (there is no motor drive or winder on DSLRs), the cameras still look the same because the manufacturers have designed the auxiliary battery packs to look like a motor or winder attachment. While most of these cameras run on AA-size batteries, it is advisable to purchase the auxiliary battery packs, since

most systems (especially those with CCD sensors) chew up batteries like jelly beans. Most of the auxiliary battery packs for DSLRs use rechargeable Lithium-ion batteries.

CAMERA SETTINGS

ISO. Digital ISO settings correlate precisely to film speeds; the slower the ISO, the less noise (the digital equivalent of grain) and the more contrast. Unlike film, however, contrast is a variable you can control at the time of capture or later in image processing (if shooting RAW files). Digital ISOs can also be increased or decreased between frames, making the process inherently more flexible than shooting with film, where you are locked into a film speed for the duration of the roll.

Shooting at higher ISOs may produce digital noise in the exposure. Substantial noise reduction has been achieved in every new generation of DSLR. Long exposures and under-

The ExpoDisc attaches to your lens like a filter and provides accurate white balance and exposure readings. It works for both film and digital.

Wallace ExpoDisc

An accessory that digital pros swear by is the Wallace ExpoDisc (www.ex poimaging.com). The ExpoDisc attaches to your lens like a filter and provides perfect white balance and accurate exposures for film or digital. The company also makes a Pro model that lets you create a warm white balance at capture. Think of this accessory as a meter for determining accurate white balance, crucial for digital imaging.

exposures can also create image noise. Many image-processing programs, like Nik Software's Dfine, contain noise-reduction filters that reduce this effect.

Contrast. As noted, professional-grade DSLRs have a setting for contrast. Most pho-

No one doubts the superb image quality of pro-quality digital cameras. This image by Nichole Van Valkenburgh is incredibly sharp and grain-free despite it being made at ISO 320. The lens used was an EOS EF 24–70mm f/2.8L USM, which offers excellent sharpness and contrast. Many photographers now believe the quality of pro DSLRs has surpassed that of medium-format film cameras.

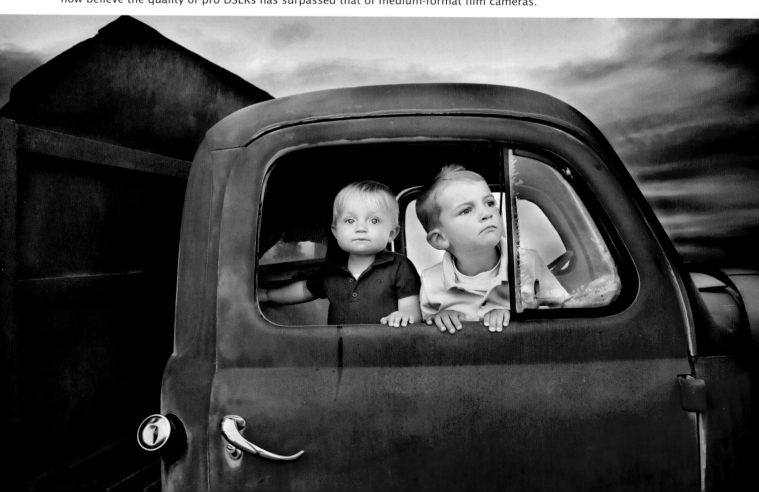

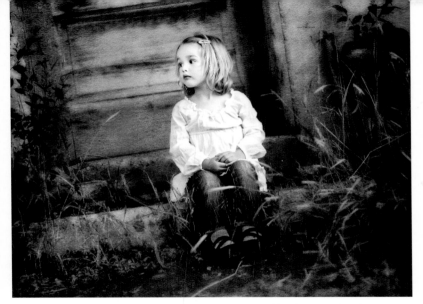

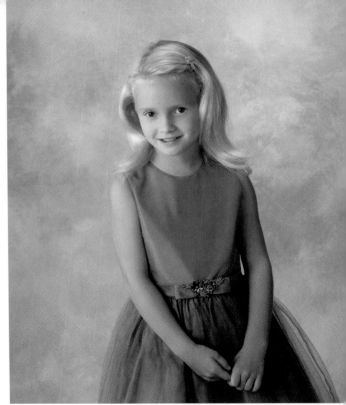

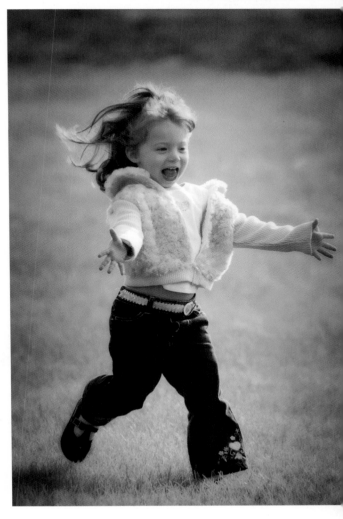

ABOVE—Just as you could increase contrast with film by overdeveloping, so you can in the digital world. Here, Nichole Van Valkenburgh used a Medium Contrast tone curve as part of her RAW file setup and added a +50 contrast setting to overcome the soft, very low-contrast lighting. The lens she used, an EF 85mm f/1.2L USM, also renders the image with excellent image contrast. **TOP RIGHT**—Tim Kelly is not only a fine portrait artist, but an equally fine technician. Tim, who is obsessed with perfect exposures, says, "Exposure is everything. In digital, exposure must be more perfect than ever." When exposure is critically perfect, the file reveals great detail and an amazingly wide dynamic range. Each Tim Kelly portrait is retouched digitally with the goal being a timeless and unforgettable portrait. **BOTTOM RIGHT**—Accurate color balance depends on skin tones being believable, whites being white, the shadows being without hue, and such familiar tones as green grass seeming accurate to the viewer. Sometimes, as here, grass is so lush and vibrant that green will begin to show up in the whites and skin tones if you don't account for it. Prem Mukherjee made this image using the camera's automatic white balance feature—an amazing technical feat considering the amount of green in the scene. Often, the photographer will shoot in RAW mode so the white balance can be corrected in RAW file processing.

tographers keep this setting on the low side at capture, because it is much easier to increase contrast after the shoot than to reduce it.

Black & White. Some digital cameras offer a black & white shooting mode. Others do not. Most photographers find the mode convenient, since it allows them to switch from color to black & white instantly. This conversion can also be done later in Photoshop.

White Balance. White balance is the camera's ability to produce correct color when shooting under a variety of different light sources, including daylight, strobe, tungsten, fluorescent, and mixed lighting. DSLRs have a variety of white-balance presets, such as daylight, incandescent, and fluorescent. Some have the ability to dial in specific color tem-

peratures in Kelvin degrees. Most DSLRs also have a provision for a custom white balance, which is essential in mixed-light conditions, most indoor available-light situations, and with studio strobes.

Choosing an accurate white-balance setting is critical when shooting high-quality JPEGs (see pages 32–33). It is not as important if shooting in RAW file mode, since RAW file processors include an extensive set of adjustments for white balance.

Color Space. Many DSLRs let you shoot in Adobe RGB 1998 or sRGB. There is con-

More on Color Space

Is there ever a need for other color spaces? Yes. It depends on your particular workflow. For example, all the images you see in this book have been converted from their native sRGB or Adobe 1998 RGB color space to the CMYK color space for photomechanical printing. As a general preference, I prefer images from photographers be in the Adobe RGB 1998 color space, as they seem to convert more naturally to CMYK. Ironically, if you go into Photoshop's color settings mode and select U.S Pre-Press Defaults, Photoshop automatically makes Adobe RGB 1998 the default color space. Out of the box, Photoshop's default color settings are for the Web, which assumes an sRGB color space, and color management is turned off.

Tim Schooler says, "With digital and the high-resolution sensors we're using now, you have to do a subtle amount of diffusion to take the edge off. But I am not a fan of over-softening skin; I think it is done too much these days. I still want to see detail in the skin, so I'll apply a slight level of diffusion on a layer, then back it off until I can see the pores. I have Capture One set for high contrast skin tones and +7 percent in color saturation, giving my finished images a little more color. Seniors seem to like it. My goal is to shoot everything as a finished image—in fact, that's how I proof. Nothing is edited or retouched before the client sees it. Then we retouch only what they ask for."

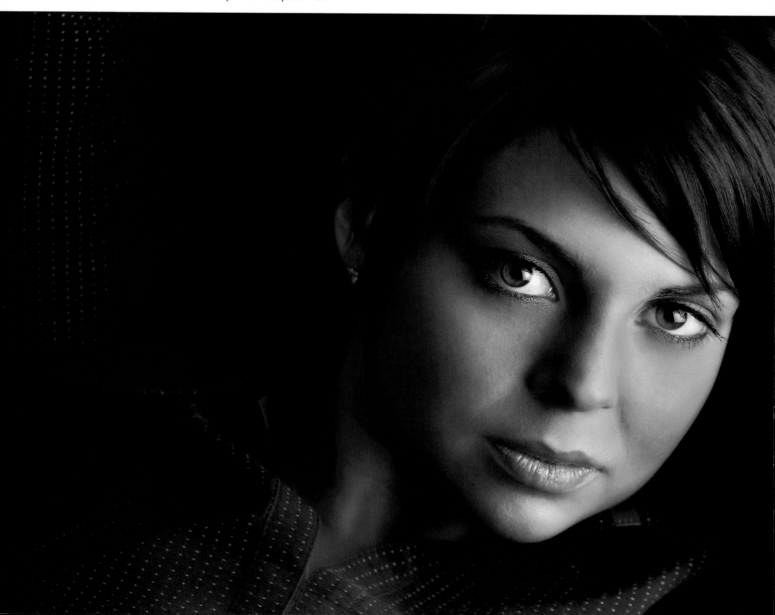

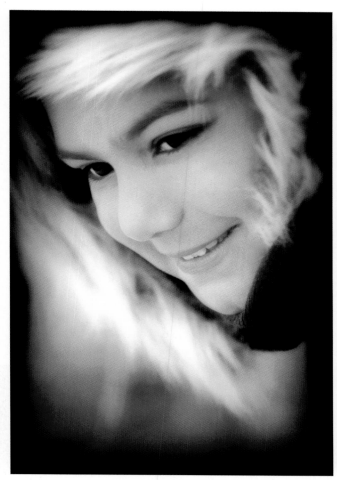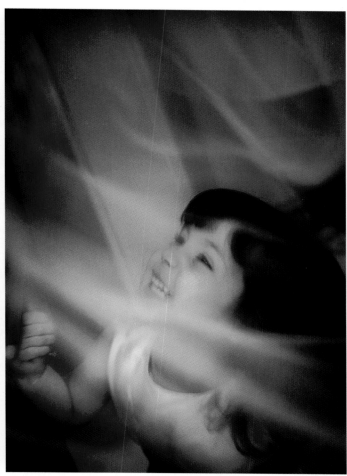

LEFT—Tero Sade, from Tasmania, is an excellent children's photographer who produces sensitively made portraits. Here, knowing that the white fur of the child's hood would be distracting at the frame edges, he artfully enclosed the face in a dark vignette, thus framing the face. The image was made at 200mm and ISO 400 at an exposure of $^1/_{500}$ second at f/2.8. RIGHT—Even though this image looks like it was taken on daylight film under tungsten lighting, it was actually made digitally with a custom white-balance setting. The photographer used bounce flash and set the white balance to shade, which is about 7500K, warming up the image substantially. Photograph by Anthony Cava.

siderable confusion over which is the "right" choice, as Adobe RGB 1998 is a wider gamut color space than sRGB. Photographers reason, "Why shouldn't I include the maximum range of color in the image at capture?" Others reason that sRGB is the color space of inexpensive point-and-shoot digital cameras and not suitable for professional applications.

Many photographers who work in JPEG format use the Adobe RGB 1998 color space all the time—right up to the point when files are sent to a printer or out to the lab for printing. The reasoning is that, since the color gamut is wider with Adobe RGB 1998, more control is afforded. Claude Jodoin is one such photographer who works in Adobe RGB 1998, preferring to get the maximum amount of color information in the original file, then edit the file using the same color space for maximum control of the image subtleties.

EXPOSURE

Latitude. When it comes to exposure, digital is not nearly as forgiving as color negative film. The latitude is simply not there. Most digital photographers compare shooting JPEGs to shooting transparency film, in which exposure latitude is usually ±$^1/_2$ stop—or less.

With transparency film, erring on either side of correct exposure is bad. When shoot-

ing digitally, exposures on the underexposed side are still salvageable, while overexposed images—images where there is no highlight detail—are all but lost forever. You will never be able to restore the highlights that don't exist in the original exposure.

For this reason, most photographers expose their digital images to ensure good detail in the full range of highlights and midtones. The shadows are either left to fall into the realm of underexposure or are "filled in" using auxiliary light or reflectors to ensure adequate detail in these areas.

Evaluating Exposure. There are two ways of evaluating the exposure of a captured image: by judging the histogram and by evaluating the image on the camera's LCD screen. By far, the more reliable is the histogram, but the LCD monitor provides a quick reference for making sure things are okay—and particularly if the image is sharp.

The histogram is a graph that indicates the number of pixels that exist for each brightness level in an individual image. The range of the histogram represents 0 to 255 steps from left to right, with 0 indicating "absolute" black and 255 indicating "absolute" white.

The histogram gives an overall view of the tonal range of the image and the "key" of the image. A low-key image has its detail concentrated in the shadows (a high number of data points near the 0 end of the scale). A high-key image has detail concentrated in the highlights (a high number of data points near the 255 end of the scale). An average-key image has detail concentrated in the midtones.

In an image with a good range of tones, the histogram will fill the length of the graph (*i.e.,* it will have detailed shadows, highlights, and everything in between). The detailed highlights will fall in the 235–245 range; the detailed blacks will fall in the 15–30 range. A histogram representing good exposure will expand to the full tonal range without it going off at the ends of the scale.

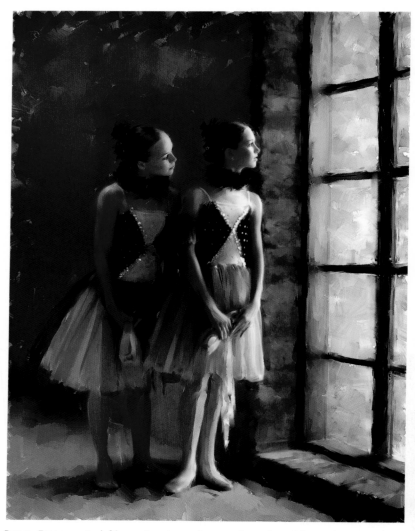

Bruce Dorn, noted filmmaker turned portrait and wedding photographer, created this beautiful image of two young ballet dancers. The image was digitally captured and then worked in Painter and Photoshop. Brush strokes cover every square inch of the image, layer upon layer, with minimal intrusion on the faces. The effect is beautiful in detail and when viewed from a distance.

Overexposure is indicated when data goes off the right end of the graph, which is the highlight portion of the histogram. This means that the highlights are lacking image detail, tone and color. In a properly exposed image, the data on the right side of the graph almost reaches the end of the scale but stops a short distance before the end.

The Team Approach

While children's portraiture takes unending amounts of patience and skill, it also takes an extraordinary amount of timing and teamwork. If you pursue this specialty, you will eventually come to the conclusion that one pair of eyes and hands is not enough—it takes a team to effectively photograph children. Sometimes it even takes you, your assistant, and the child's mother to make things work.

Often, a husband and wife act in concert to create children's portraits. One will be the "entertainer," using props and a soothing voice, stimulating the child to look alert and in the right direction for the camera. The other will be the technician, making the images, adjusting lighting, camera settings, and composition, and trying to be as unobtrusive as possible. The "entertainer" works at getting the child's attention without overstimulation, which often brings the session to a screaming (literally) halt.

Tero Sade's goal is to drive the center of interest in the photo toward the eyes. He also likes to crop images tightly. Here, because of the girl's windblown hair, her eyes are partially obscured, making the viewer work harder to arrive at the center of interest. Notice the tight vignette that frames the image.

When an image is underexposed, the information in the histogram falls short of the right side and bunches up on the left side. Although it is true that an underexposed image is preferable to an overexposed one, nothing will ever look as good as a properly exposed image. You can correct for underexposure in Photoshop's Levels or Curves adjustments, but it is time-consuming to adjust exposure in this manner.

METERING

Reflectance Meter. Because exposure is critical for producing fine portraits, it is essential to meter each scene properly. Using an in-camera light meter may not provide consistent, accurate results. Even with sophisticated multi-pattern, in-camera reflectance meters, brightness patterns can sometimes influence the skin tones. The problem arises from the meter's function, which is to average all of the brightness values it sees to produce a generally acceptable exposure. Essentially, the in-camera

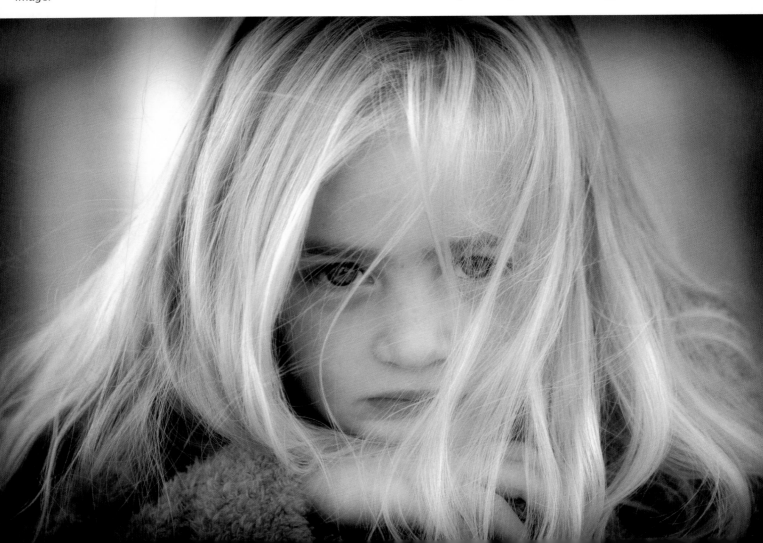

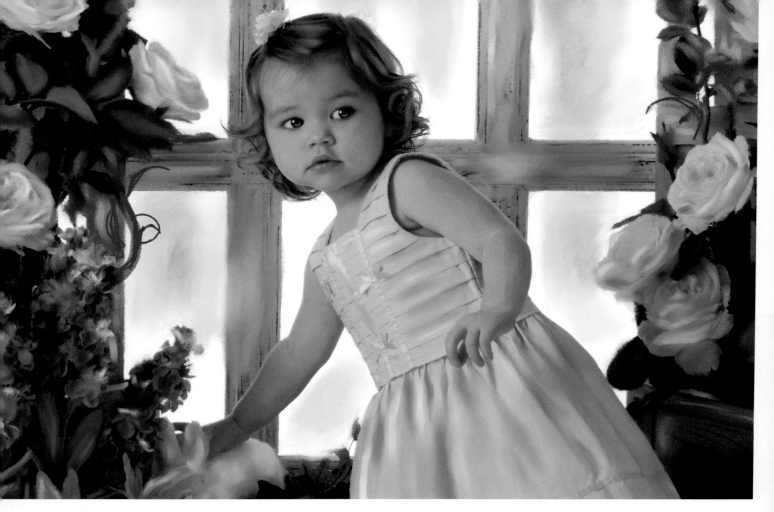

meter wants to turn everything it sees into 18-percent gray, which is dark even for well sun-tanned or dark-skinned people.

If using the in-camera meter, you should take a meter reading from an 18-percent gray card held in front of the subject. The card should be large enough to fill the frame. If using a handheld reflected-light meter, make it a habit do the same thing; take a reading from an 18-percent gray card or a surface that approximates 18-percent reflectance.

Incident Light Meter. The preferred type of meter for portraiture is the handheld incident light meter. This meter does not measure the reflectance of the subjects but determines the amount of light falling on the scene. In use, stand where you want your subjects to be, point the hemisphere (dome) of the meter directly at the camera lens, and take a reading. This type of meter yields extremely consistent results because it is less likely to be influenced

by highly reflective or light-absorbing surfaces. (*Note:* If metering a backlit scene with direct light falling on the subject, shield the meter's dome from the backlight. The backlight will influence the exposure reading and your priority should be the frontal planes of the face.)

Incident Flashmeter. The ultimate incident meter is the handheld incident flashmeter, which also reads ambient light. There are a number of models available, but they all allow you to meter both the ambient light and the flash output at the subject position.

The problem is that you either need to have an assistant trip the strobe for you while you hold the meter, or have the subject hold the meter while you trip the strobe to get a reading. You can also attach a PC cord to the meter and trigger the strobe that way, but PC cords can be problematic—particularly when there are children running around.

Digitally captured portraits like this one can be taken right away into programs such as Photoshop and Painter for artistic interpretation. Here, a combination of Photoshop's filters and Painter's ability to apply brush strokes to the photograph have created a painterly masterpiece. Photograph by Deborah Lynn Ferro.

Many photographers now shoot RAW to preserve as much image data as possible and to allow for adjustments in RAW file processing. Others prefer the speed of working in JPEG Fine mode. Exposure is critical when shooting JPEGs, especially for preserving highlight detail. This charming portrait of two brothers was made by Vicki Taufer.

A better solution is to fire the strobe remotely with a wireless triggering device. These devices use transmitters and receivers to send signals to and from the flash or flashes that are part of the system. There are several types of wireless triggering devices on the market. Optical slaves work with bursts of light, such as that from a single electronic flash. The other lights, equipped with optical receivers, sense the pulse of the electronic flash and fire at precisely the same time. Radio slaves send radio signals to the strobes in either analog or digital form. These systems can be used almost any-

where and they aren't adversely affected by local radio transmissions.

For a completely wireless strobe setup, you can use a separate wireless transmitter for the handheld exposure meter. This allows you the ultimate freedom in cordless metering, since you can meter the ambient and flash exposures from the camera position without the need of an assistant or PC cord. The unit wirelessly fires the flash (or multiple flashes) in a similar manner to the transmitter on the camera.

In order to minimize the number of cords traversing the set—a danger not only to small

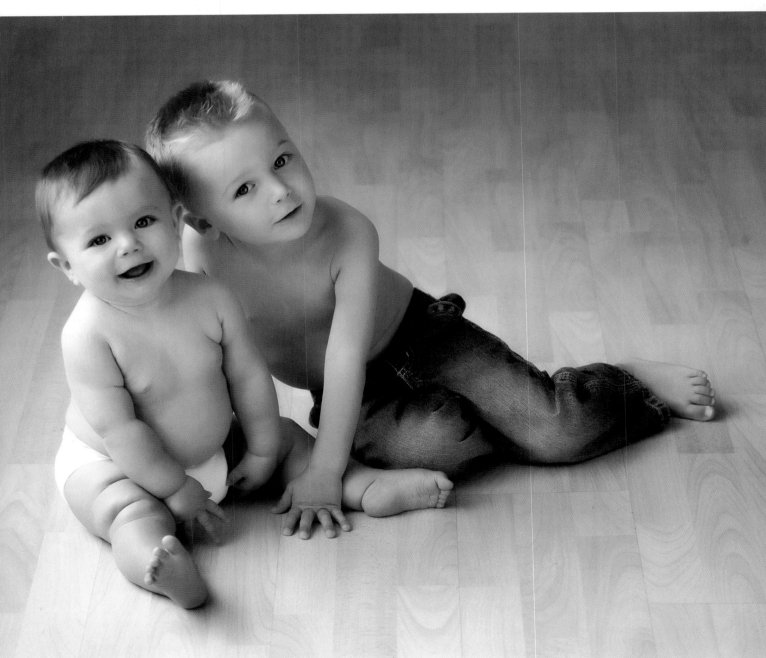

children but harried photographers—many photographers opt for the wireless triggering of all their studio lights.

Spotmeter. A good spotmeter is a luxury for most photographers, but it is an invaluable tool—especially if you are working outdoors. The value of a spotmeter is that you can use it to compare exposure values within the scene, something you can't do as critically with an incident meter. For example, you can look at the highlights in your subject's hair, which may be illuminated by sunlight, and compare that reading to the exposure on their face, which may be illuminated by a reflector. If the hair is more than two stops brighter than your exposure, you will know that you need to adjust one or the other to maintain good detail in both areas. Similarly, in the studio, you can use

the spotmeter to check on the values created by various lights, reading them individually or collectively.

FILE FORMAT

DSLRs offer the means to shoot in several modes, but the two most popular ones are JPEG and RAW. Each mode has some advantages and drawbacks.

JPEG. Shooting in JPEG Fine mode (also called JPEG Highest Quality) yields smaller files, so you can save more images per media card or storage device (compared to RAW files). The smaller file size also allows you to work much more quickly. However, your options for correcting the image after the shoot aren't as powerful as with RAW files. JPEG is also a "lossy" format, meaning that the images

Craig Kienast often uses Painter to merge his backgrounds and subjects, which are often the same tones, and create an entirely different portrait than was originally conceived.

are subject to degradation by repeated opening and closing. Photographers who shoot in JPEG mode either save the file as a JPEG copy each time they work on it, or save it to a "lossless" TIFF format, so it can be saved again and again without degradation.

RAW. RAW files offer the benefit of retaining the highest amount of image data from the original capture. This gives you the ability to almost completely correct for underexposure. However, more data means larger files; if you need faster burst rates, RAW files will slow you down (although newer cameras with bigger buffers—and buffer upgrades for existing cameras—have improved the situation). RAW files will also fill up your storage cards or microdrives more quickly than JPEGs.

Shooting in the RAW mode requires the RAW file-processing software to translate the file information and converts it to a useable format. Only a few years ago, RAW file-processing was limited to the camera manufacturer's own software, which was often slow and difficult to use. With the introduction of independent software like Adobe Camera Raw and Phase One's Capture One DSLR, RAW file processing is not nearly as daunting.

METADATA

DSLRs give you the option of tagging your digital image files with data, which often includes the image's date, time, and camera settings. To view this information in Photoshop, go to File > File Info and look at the EXIF

Tim Schooler shoots all his senior images in RAW, then uses Phase One's Capture One to process the RAW image files. In processing, he uses a +7 bump in contrast and a slight increase in saturation in order to deliver rich tones in his senior portraits.

data in the pull-down menu. Here, you will see all of the data that the camera automatically tags with the file. You can also add your copyright notice to this data, either from within Photoshop or from your camera's metadata setup files. Adobe Photoshop supports the information standard developed by the Newspaper Association of America (NAA) and the International Press Telecommunications Council (IPTC) to identify transmitted text and images. This standard includes entries for captions, keywords, categories, credits, and origins from Photoshop.

REFORMAT YOUR CARDS

After you back up your original files to at least two sources, it's a good idea to reformat the media cards. It isn't enough to delete the im-

LEFT—Imagenomic sells a remarkable retouching plug-in called Portraiture.

BELOW—Tim Schooler's retouching is impeccable. He often uses Imagenomic's Portraiture II plug-in on a separate layer in Photoshop. He softens and smooths the skin and then brings back the underlying original layer just enough to reveal the texture of the skin.

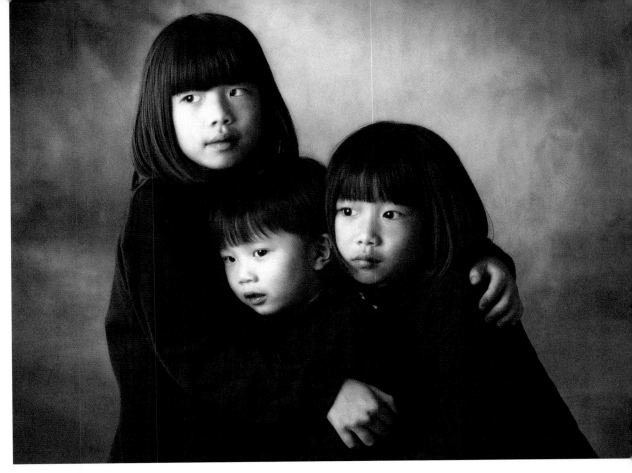

This beautiful portrait by Vicki Taufer was made at ISO 100. Film grain was added in postprocessing in order to give the image a timeless, textural feeling.

ages; extraneous data may remain on the card, possibly causing data interference. After reformatting, you're ready to use the card again.

RETOUCHING

While retouching is far less necessary in most children's portraits, it is a necessity for older kids, like high school seniors. There are also many instances of infant acne, which can manifest itself as early as three weeks from birth and linger for months. Because a baby's skin is so sensitive, there are no real remedies (such as creams or lotions) that can be used. You shouldn't even cleanse the skin too often, according to several infant web sites.

There are many different ways to retouch these skin problems. One of the most unique products I have discovered, from talking with senior expert Tim Schooler, is a Photoshop plug-in called Portraiture II from Imagenomic (www.imagenomic.com/pt.aspx). This plug-in intelligently smooths and removes imperfections while preserving skin texture and other important details, such as hair, eyebrows, eyelashes, etc. The Portraiture plug-in uses an auto-masking feature to create an optimal skin-tone mask for the image, helping to automate the effect. Additionally, the software features a size parameter, allowing you to optimize the retouching to match the size of the print. Soft-focus, warmth, and brightness/contrast controls are also available with this plug-in—as well as a glamour effect. This is by far one of the best tools I've seen; while tweaking each image might still be needed, it eliminates hours of tedious retouching.

3. STUDIO LIGHTING

When kids are photographed in the studio, the lighting setups you use should be simplified for active subjects and short attention spans. Elaborate lighting setups that call for precise placement of backlights, for example, should be avoided in favor of a single broad backlight that creates an even effect over a wider area. In fact, when photographing children's portraits, if one light will suffice, don't complicate the session. Simplify!

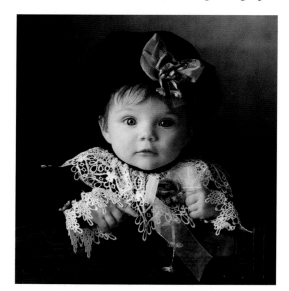

Tim Kelly is a master of lighting and, like the great portrait artists throughout history, he creates light that seems to emanate from within the image. His standard tools are softboxes (large ones—4x6 and 3x4 feet) and strip lights for hair and background, with reflectors and gobos everywhere to modify little subtleties of the lighting. This remarkable portrait is titled *To the Nines.*

THREE DIMENSIONS AND ROUNDNESS

A photograph is a two-dimensional representation of a three-dimensional subject. It is, therefore, the job of the portrait photographer to show the contours of the subject—and particularly the face. This is done with highlights and shadows. Highlights are areas that are illuminated by a light source; shadows are areas that are not. The interplay of highlight and shadow creates roundness and shows form. Just as a sculptor molds clay to create depth, so light models the shape of the face to give it the appearance of depth and form.

QUALITY OF LIGHT

Light can be sharp or soft. Which quality a given light source will display is a function of its size in relation to the subject.

Size of the Source. Small, undiffused light sources produce light that is crisp with well-defined shadow areas and good rendering of texture. These sources can create a portrait that is quite dramatic. Large light sources, on the other hand, produce a smoother, more gentle look that is usually considered more flattering for portraits—especially of children.

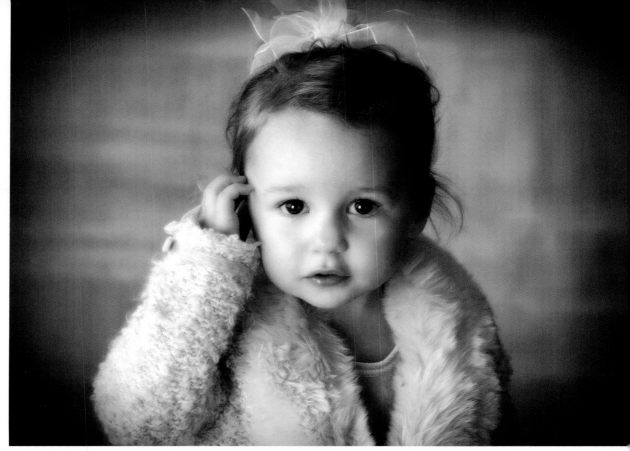

Diffused light sources, like the softbox used here, can often be used without a fill light. Vicki Taufer added a small reflector on the floor to the child's left to kick up a little of the stray light into the shadow areas.

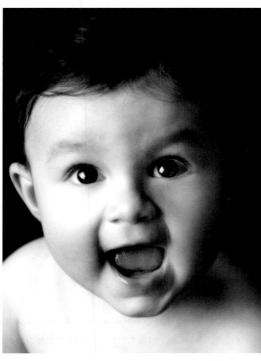

The proximity and size of the light controls its softness. Here, Kevin Jairaj used a very large softbox close to the baby and silver reflectors on the floor beneath the set. The light still has dimension and creates a pleasant cross lighting pattern because it is positioned to the side and almost behind the child. The child is delighted by whatever sound Kevin or Mom is making.

Distance to Subject. When used close to a subject, even a small light source can produce a soft effect with more open shadows than when the same light is used at a distance. Conversely, a large light that is placed at a distance can begin to produce a more specular quality of light, despite its inherent size.

Diffused *vs.* Undiffused Light. Undiffused light, like that produced by a parabolic reflector, is sharp and specular in nature. It produces crisp highlights with a definite line of demarcation at the shadow edge. These light sources take a great deal of practice to use well, which is probably why they are not used too much anymore—especially for kids' portraits.

Diffused light sources—softboxes, umbrellas, and strip lights—are much simpler to use because they scatter the outgoing beams of light as they pass through the diffusion material. This bathes the subject in light that is softer and significantly less intense. This makes them a good choice for lighting children's portraits. These bigger light sources also tend

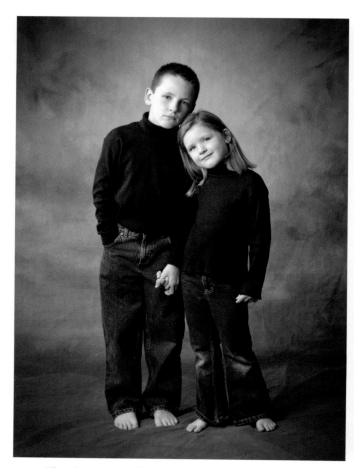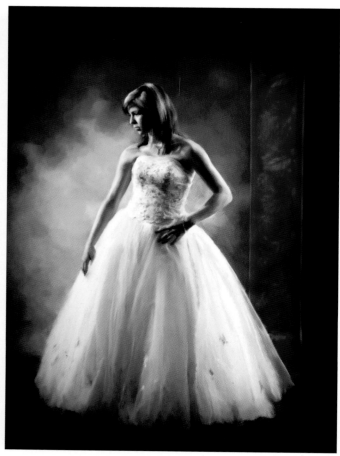

LEFT—The closer the diffused light source is to the subject, the softer the light will be. Here, the softbox was just out of view of the lens, as close as possible to the brother and sister without being in the frame. Because the light was moved toward the front so the brother wouldn't block the light on the sister, no fill light was used. Photograph by Vicki Taufer. RIGHT—With undiffused light, there are distinct lines of demarcation between the shadows and highlights. Here, John Ratchford used grid lighting from above and behind the young lady for a dramatic effect. Notice the sharp falloff of highlight to shadow along her cheekbone.

to spread the light over a wider area, which is perfect for small, squirmy subjects who can change positions frequently and quickly.

An additional advantage of using diffused light is that, often, you don't need a separate fill light; the highlights tend to "wrap around" the contours of the face. If any fill source is needed, a reflector will usually do the job.

A single softbox will produce beautiful soft-edged light, ideal for illuminating little faces. Softboxes are highly diffused and may even be double-diffused with the addition of a second scrim over the lighting surface. Also, some softbox units accept multiple strobe heads for increased lighting power and intensity.

Umbrellas, including the shoot-through type, can be used similarly and are a lot easier

to take on location than softboxes, which have to be assembled and placed on sturdy light stands with boom arms. Photographic umbrellas are either white or silver. A silver-lined umbrella produces a more specular, direct light than does a matte white umbrella. It will also produce wonderful specular highlights in the overall highlight areas of the face. Some umbrellas come with intermittent white and silver panels. These produce good overall soft light but with specular highlights. They are often referred to as zebras.

Umbrellas, regardless of type, need focusing. By adjusting the length of the exposed shaft of the umbrella in its light housing you can optimize light output. When focusing the umbrella, the modeling light should be on so

Timing

When working with strobes, which have preset recycle times, you cannot shoot as you would under available light—one frame after another. You have to factor in at least these two things: (1) the strobes may startle the child initially, thus curtailing a fun time; and (2) while you're waiting for the flash to recycle, you may see three or four pictures better than the one you just took. Experience and patience are keys in the latter situation; you don't necessarily have to jump at the first opportunity to make an exposure. Here's where working with a trusted assistant can really help, since you can gauge by their activity if the event is building or subsiding. Out of every sequence of possible pictures, one will be the best. Assume you'll only get one chance and your patience will often be rewarded. Perhaps the best advice is always to be ready. Preparedness often leads to success.

Mark Nixon solved the problem of light falloff with a wide group by using two softboxes adjacent to one another to camera left. The softboxes were feathered across the group so that the lighting pattern was preserved and so that the lighting was even from the face nearest the lights to the face farthest from the light sources.

you can see how much light spills past the umbrella surface. The umbrella is focused when the circumference of the light matches the perimeter of the umbrella.

Again, keep in mind that the closer the diffused light source is to the subject, the softer the quality of the light will be. As the distance between the light source and the subject increases, the diffused light source will look less like diffused light and more like direct light.

LIGHT POSITIONS AND FUNCTIONS

Main Light and Fill Light. The two basic lights used in portraiture are called the main light and the fill light. Traditionally, the main and fill lights were high-intensity lights fitted with either reflectors or diffusers. Polished pan reflectors (also called parabolic reflectors) are silver-coated "pans" that attach to the light housing and reflect the maximum amount of light outward in a focused manner. Most photographers don't use parabolic reflectors anymore, opting for diffused main- and fill-light sources like umbrellas or softboxes. Diffused

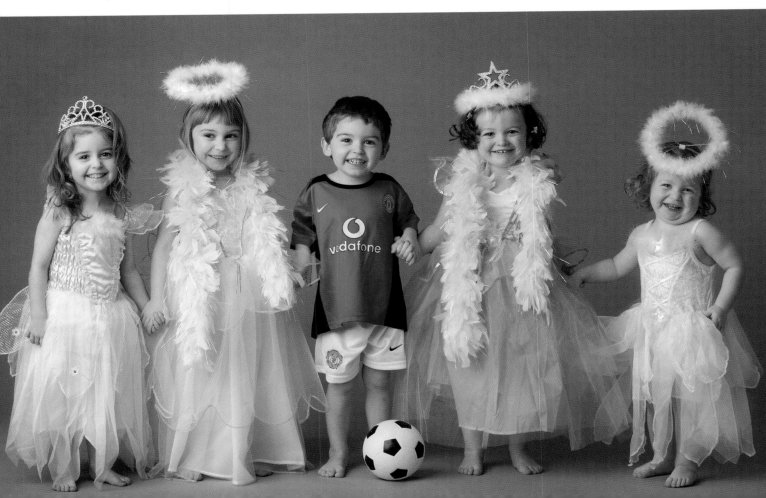

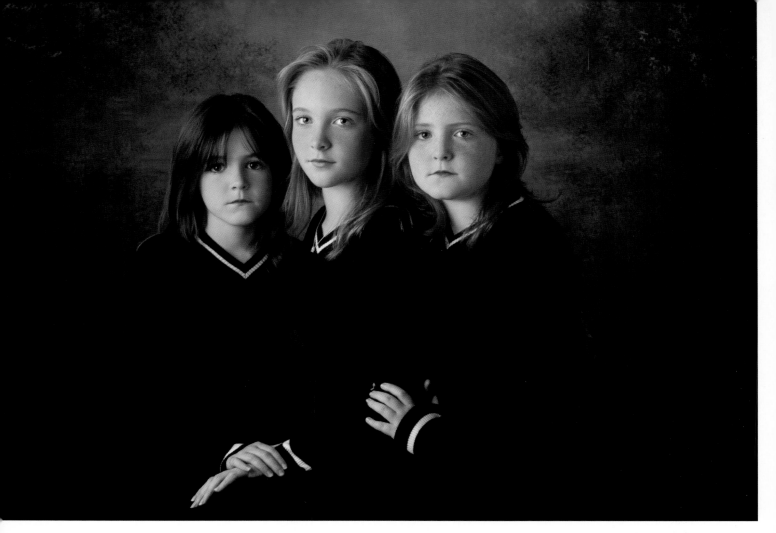

light sources are ideal for kids because they are large and forgiving, meaning that the child can move around and not move out of the light.

When using a diffused main light source, the fill source is often a reflector—a portable, highly reflective surface used to bounce light (from the main light) into the shadows of the face and body of the subject. If using a diffused light source for the fill light, however, be sure that you do not spill light into areas of the scene where it is unwanted, such as the background or the camera's lens.

Hair Light. In a diffused lighting scenario, the hair light for kids' portraits is a smaller diffused light source, usually suspended on a boom and highly maneuverable so that it can add a subtle highlight to the child's hair and head. Sometimes called striplights, these small softboxes are positioned behind and above the subject, just out of the camera's view.

Background Light. If a background light is used, it is diffused and washes the background with light so that it does not go dull in the final photo.

Kicker Lights. Kickers are optional lights used similarly to hair lights. These add highlights to the sides of the face or body to increase the feeling of depth and richness in a portrait. Kickers are used behind the subject and produce highlights with great brilliance, because the light just glances off the skin or clothing. Since they are set behind the subject, barn doors should be used to avoid creating lens flare.

LIGHTING STYLES

Broad *vs.* Short Lighting. There are two basic types of portrait lighting. Broad lighting means that the main light illuminates the side of the face turned toward the camera. Short

Portrait master Tim Kelly blends his lights so that they are almost not visible. Here, he used large softboxes for fill and main lights, placing them to the left of the subjects. He added a portable reflector opposite those lights for additional fill. For a background light, he used a grid spot on a stand to camera right; for a background/hair light, he used a 10x30-inch Softstrip with louvers. The highlights caused by the hair light and background light are very subtle.

In this wonderful portrait of a baby in a peach basket, John Ratchford used a strong lighting ratio with no fill. He did, however, use a kicker on the shadow side of the set to produce an edge light along the baby's arm and a highlight along the edge of the face, which provided much-needed tonal separation from the dark background.

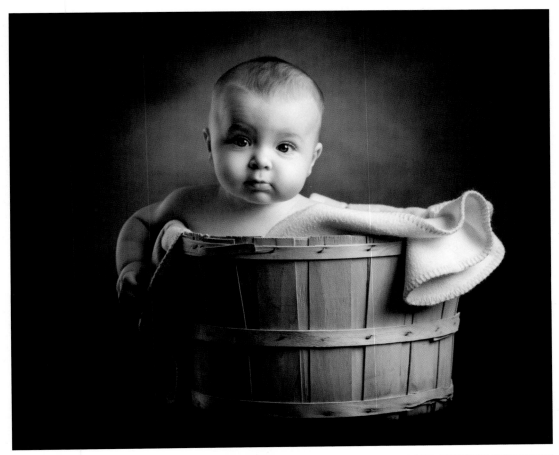

A very large softbox was used close to the baby for ultrasoft lighting. To get a pure white background, the white seamless was illuminated from either side of the set. The background lights were 1 to 1.5 stops brighter than the main light, which was set to f/11. Photograph by Mark Nixon.

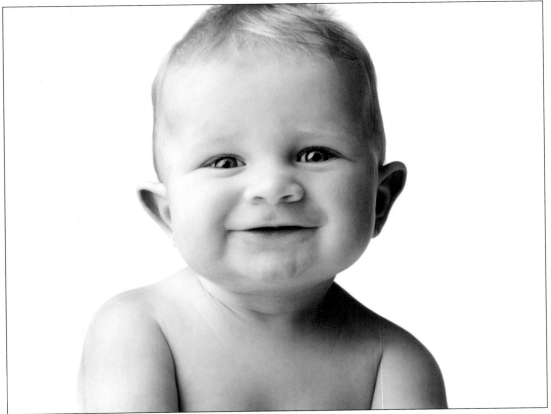

lighting means that the main light is illuminating the side turned away from the camera.

Broad lighting is used less frequently than short lighting because it flattens facial contours. Short lighting emphasizes facial contours and can be used as a corrective lighting technique to narrow a round or wide face. When used with a weak fill light, short lighting produces dramatic lighting with bold highlights and strong shadows.

The Basic Lighting Patterns. Although there are five distinct lighting patterns in traditional portraiture (Paramount, loop, Rembrandt, split, and profile lighting), they are seldom used in children's portraiture because they call for sharper, less diffused main lights. When you use a large, diffused light source—the type of main light usually employed in children's portraiture—its effects will be less visible, since the shadow edge is much softer.

What is important to remember is that you should define a lighting pattern by making the main light stronger than the fill light. The fill is necessary to lighten shadows that go unilluminated, but the most important light is the main light. It is usually positioned above and to one side of the child, producing a corresponding shadow pattern on the side of the child's face opposite the light source. Different effects are achieved by elevating or lowering the main light and moving it to one side of the subject. The lighting patterns are produced by the main light, which only lights the highlight side of the face.

There are a few important things to remember about the main-light position. When placed high and on axis with the subject's nose, the lighting will be nearly overhead. When this occurs, shadows will drop under the nose and chin and, to some extent, the eye sockets. The eyelashes may even cast a set of diffused shadows across the eyes, and the eyes themselves will need a fill source to open up the shadows and to get them to sparkle.

As you move the main light lower and far-

ther to the side of the subject, the roundness of the face becomes evident. There will also be more shadow area visible on the side of the face opposite the main light. As a general rule, most portrait photographers start with the main light roughly 30 to 45 degrees from the camera/subject axis and at a medium height.

Catchlights. Catchlights are small, pure white highlights that make the eyes look alive and vibrant. Without catchlights, subjects often have a vacant appearance. The catchlights you create will be the same shape as your main light source—if using a softbox, the catchlights will be square; when a striplight is

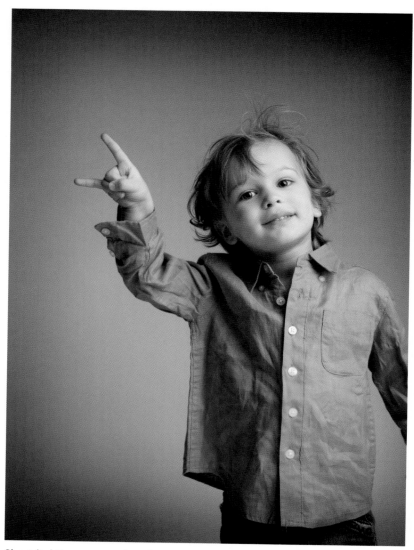

Short lighting means that the main light is illuminating the side of the face turned away from the camera. The lighting ratio in this charming portrait is pretty normal, around 3:1. Photograph by Jim Garner.

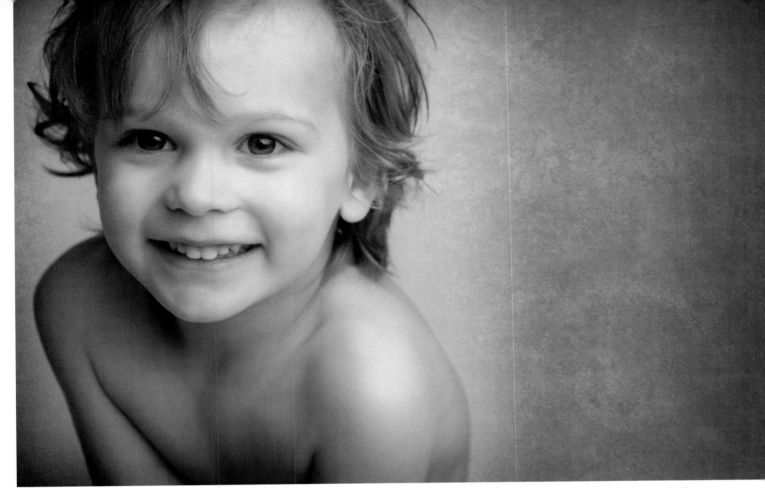

Broad lighting means that the main light illuminates the side of the face turned toward the camera. The lighting ratio here is slightly lower than the 3:1 ratio in the facing-page photo by Jim Garner.

used, the catchlights will be rectangular and elongated, and so on. If you use a second light or a reflector that adds light to the eyes, this too will be mirrored in the eyes. This secondary catchlight can be retouched after the shoot for a more natural appearance.

Feathering

Feathering means using the edge of the light source rather than the hot core. If you aim a light directly at your subject, you will find that—while the strobe's modeling light may trick you into thinking the lighting is even—it is very hot in the center, producing areas of blown-out highlights. Feathering helps to even the light across your subject so that you are using the light source's dynamic edge, rather than the core of the light. This is achieved by aiming the light past the subject or up and over the subject. Since this means you are using the edge of the light, you have to be careful not to let the light level drop off. This is where a handheld incident flashmeter is of great value. Always verify your lighting with the meter and by testing a few frames.

LIGHTING RATIOS

The term "lighting ratio" is used to describe the difference in intensity between the shadow side and highlight side of the face in portraiture. It is expressed numerically as a ratio. A ratio of 3:1, for example, means that the highlight side of the face has three units of light falling on it, while the shadow side has only one unit of light falling on it. Ratios are useful because they determine how much local contrast there will be on the subject. Since they reflect the difference in intensity between the main light and the fill light, the ratio is also an indication of how much shadow detail you will have in the portrait.

Calculating. There is considerable debate and confusion over the calculation of light ratios. This is principally because you have two systems at work, one arithmetic and one logarithmic. F-stops are in themselves a ratio be-

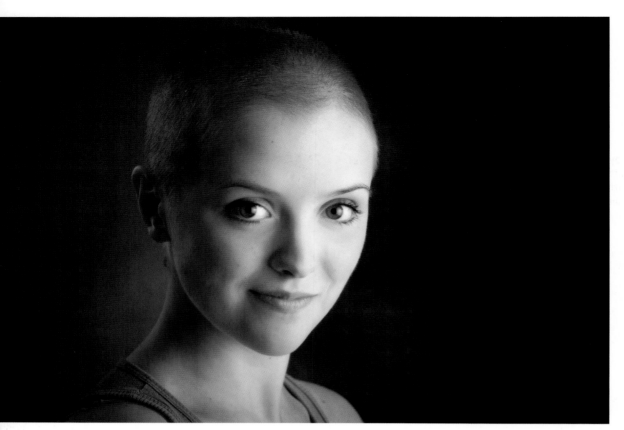

John Ratchford documented Elsie's fight against cancer for a full year. She was in and out of his studio as much as she was in and out of the hospital. Here John used a single diffuse light source as a main light and no fill in order to sculpt her nice cheekbones with shadow. So the shadow area would not go too dark, he used a weak kicker to provide a subtle separation between her head and the dark background. The lighting ratio here is fairly strong, about 4:1.

tween the size of the lens aperture and the focal length of the lens, which is why they are expressed as f/2.8, for example. The difference between one f-stop and the next full f-stop is either half the light or double the light. For example f/8 lets in twice as much light through a lens as f/11 and half as much light as f/5.6. However, when we talk about light ratios, each full stop is equal to two units of light. Each half stop is equal to one unit of light. This is, by necessity, a suspension of disbelief, but it makes the light ratio system explainable and repeatable.

In portrait lighting, the fill light is always calculated as one unit of light, because it strikes both the highlight and shadow sides of the face. The amount of light from the main light, which strikes only the highlight side of the face, is added to that number. For example, imagine you are photographing a small child and the main light is one stop greater than the fill light. These two lights are metered independently and separately. The one

unit of the fill light (because it illuminates both the shadow and highlight sides of the faces) is added to the two units of the main light (which lights only the highlight side of the face), indicating a 3:1 ratio.

Ratios for Children. You will most often see children photographed with low to medium lighting ratios of 2:1 to 3.5:1.

A 2:1 ratio is the lowest lighting ratio you should employ. It shows only minimal roundness in the face. In a 2:1 lighting ratio the main and fill light sources are the same intensity (one unit of light falls on the shadow and highlight sides of the face from the fill light, while one unit of light falls on the highlight side of the face from the main—1+1=2:1).

A 3:1 lighting ratio is produced when the main light is one stop greater in intensity than the fill light (one unit of light falls on both sides of the face from the fill light, and two units of light fall on the highlight side of the face from the main—2+1=3:1). This ratio is the most preferred for color and black &

white because it will yield an exposure with excellent shadow and highlight detail. It shows good roundness in the face and is ideal for rendering average-shaped faces.

Stronger ratios are more dramatic, but less appropriate for kids. It should be noted that "corrective" lighting ratios are rarely used with children. With adults who have large or wide faces, a split lighting pattern and a 4:1 ratio will noticeably narrow the face. With children, wide faces are a happy fact of life—they make little subjects look cherubic.

SOME FAVORITE SETUPS

Large Softboxes. Very large light sources—larger than most children—are a popular choice for photographing children. Photogra-

In this delicate portrait by Deborah Lynn Ferro you can see how the main light establishes the lighting pattern and the fill light places light in the shadows. This lighting ratio is very delicate, in the 2:1 range. The main light produces a Rembrandt pattern—but the lighting is so soft that it's difficult to see the traditional triangular highlight on the shadow side of the face.

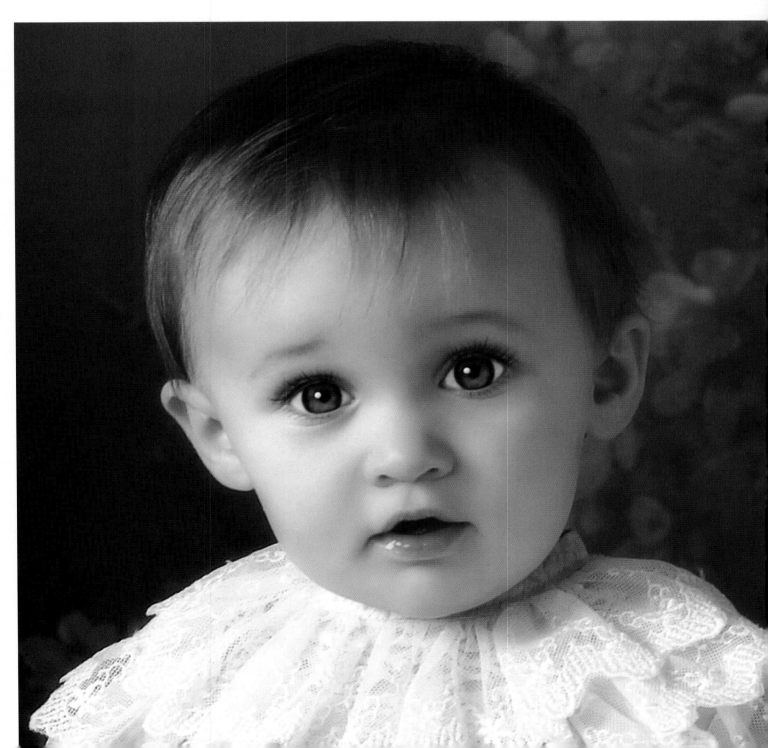

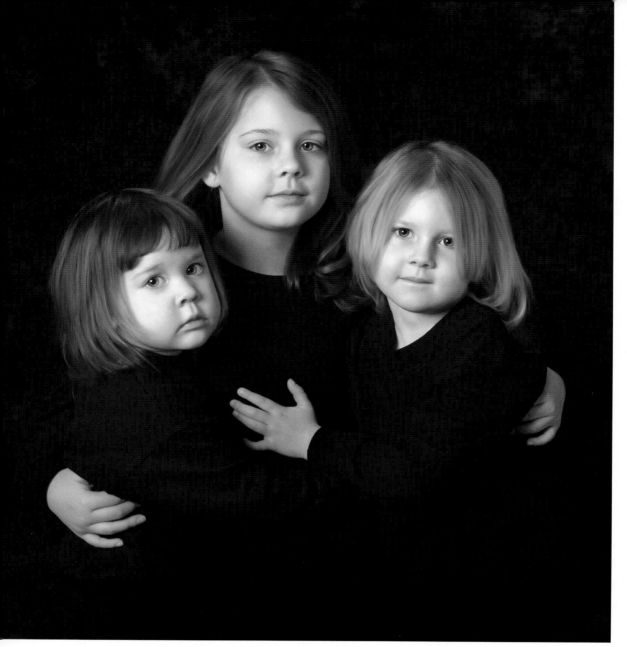

This is a beautifully executed portrait of three sisters. To create it, Brian Shindle used a single large softbox to the left of the camera and a large white reflector to the right of the camera. A diffused hair light was used from above. Brian removed the second set of catchlights in the eyes and reshaped the rectangular catchlights to form a circular pattern, giving the image a more traditional feel. Note the triangular shape used to form the composition.

pher Brian Shindle uses a big 4x6-foot softbox and a secondary 2x4-foot softbox to wash his small clients in soft, directional light.

Softbox and Silver Reflector. Another popular children's lighting setup is done with a softbox and silver reflector with the child in a profile pose. The softbox is positioned close to and facing the child. This lights the frontal planes of the face straight on—but because the face is then photographed from the side, the light is actually skimming the skin's surface. The light is feathered toward the camera so that the edge of the light is employed. A silver reflector, positioned below camera level be-tween the child and the camera is adjusted until it produces the maximum amount of fill-in. (*Note:* It is important to use a lens shade with this type of lighting, because you are feathering the softbox toward the lens. You can, of course, feather the light away from the lens, toward the background, but the shot will be more difficult to fill with the reflector.)

4. OUTDOOR AND NATURAL LIGHTING

Youngsters are often more at ease in natural surroundings than they are in the confines of a studio. Fortunately, outdoor settings offer countless lighting possibilities. You can photograph children in backlit, sidelit, or frontlit situations; in bright sun or deep shade. The ability to control outdoor lighting is really what separates the good children's photographers from the great ones. Learning to control, predict, and alter daylight to suit the needs of the portrait will help you create elegant natural-light portraits consistently.

Just as in the studio, it is important that outdoor images appear to be lit by a single light. This is a fundamental in portraiture. Unlike the studio, where you can set the lights to obtain any effect you want, in nature you must use the light that you find.

COMMON PROBLEMS

One thing you must be aware of outdoors is separating the subject from the background. Dark hair against a dark green background will create a tonal merger. Adding a controlled amount of flash fill or increasing the background exposure will solve the problem.

Sometimes, you may choose a beautiful location for a portrait, but find that the background is totally unworkable because of a bald sky, a cluttered look, or mottled patches of sunlight. The best way to handle such backgrounds may be later in postproduction. Any number of softening, vignetting, diffusion, or grain effects can be added to the background alone to solve the problem.

Elizabeth Homan capitalized on some beautiful "found" lighting—late afternoon sun, rim-lighting the trellis and young girl, and a bright house close by reflecting direct sun back onto the scene as softened shade. Elizabeth enhanced the portrait by softening the background and painting details into the flowers in the arbor and greenery. All in all, it's a lovely portrait.

You may also encounter an excessively cool coloration in portraits taken in shade. If your subject is near a grove of trees surrounded by foliage, there is a good chance that green will be reflected onto your subject. If your subject is exposed to clear, blue open sky, there may be an excess of cyan in the skin tones. While you are setting up, your eyes will acclimate to the off-color rendering, and the color cast will seem to disappear. To correct this, take a custom white balance reading or set your camera to automatic white balance. You can also pho-

tograph your session in the RAW mode, then fine-tune the color balance during the image-processing phase to get a completely neutral skin tone rendering.

DIRECT SUNLIGHT

It is important to check the background while composing any portrait made in direct sunlight. Since there is considerably more light than in a portrait made in the shade, the ten-

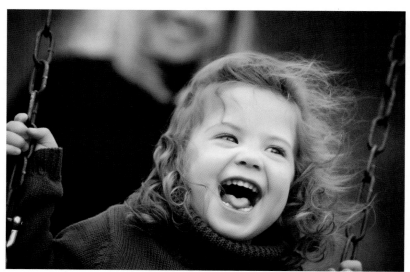

RIGHT—One of the problems in working outdoors is overhead shade, which casts dark shadows in the eye sockets, under the nose and under the lower lip. That situation was avoided by Prem Mukherjee photographing this youngster on a swing, where once every swing she would be looking up into the sky, thereby eliminating those shadows. The exposure was made at $^1/_{500}$ second at f/4 at ISO 400 with a 135mm lens. BELOW—Another good way to negate the effects of overhead shade is to keep the contrast of the image on the low side. The more contrast in the image, the more likely the extremes of shadow and highlight will be noticeable. In this image, Kersti Malvre lowered the contrast considerably in printing.

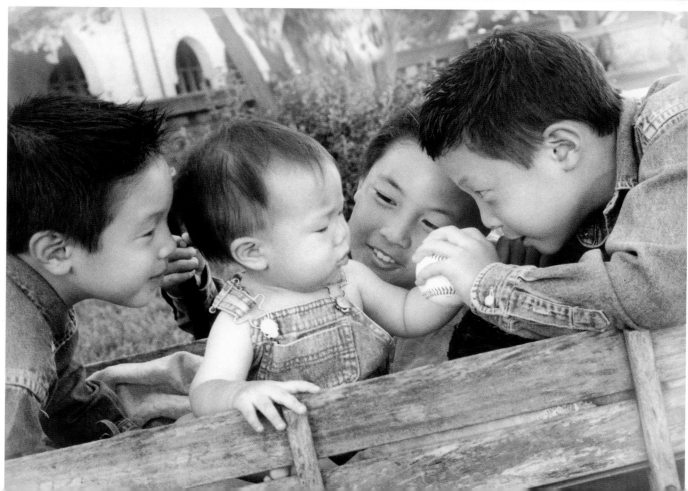

dency is to use an average shutter speed like $\frac{1}{250}$ second with a smaller-than-usual aperture like f/11. Smaller apertures will sharpen up the background and take attention away from your subject. You should always preview the depth of field to analyze the background sharpness. Use a faster shutter speed and wider lens aperture to minimize background effects in these situations.

Backlighting. To take advantage of golden sunlight, turn your subjects so they are backlit. This voids the harshness of the light and prevents subjects from squinting. Of course, you need to fill-in the backlight with strobe or reflectors. You also need to be careful not to underexpose. It is really best to use a handheld incident meter in backlit situations, but if you have no meter other than the in-camera one, move in close to take your reading on the subject. In backlit portraits, it is best to give each frame an additional $\frac{1}{3}$ to $\frac{1}{2}$ stop of exposure in order to open up the skin tones.

Cross Lighting. If the sun is low in the sky, you can use cross lighting, otherwise known as split lighting, to get good modeling on your subject. Position the child so that the light is to the side but almost behind him or her. Almost half of the face will be in shadow while the other half is highlighted. You must be careful to position the subject's head so that the sun's sidelighting does not hollow out the eye sockets on the highlight side of the face. You must also fill in the shadow side of the face. If using flash, the flash exposure should be at least a stop less than the ambient light exposure.

Softening with Scrims. "Scrim" is a Hollywood lighting term used to define a large sheet of mesh or translucent nylon material that diffuses a direct light source. Scrims are often seen on large, portable frames on movie sets. The frame is hoisted into position between the light source and the set and tied off with ropes so that the light is diffused and softened, giving a soft skylight effect.

The same technique can be used with still photography using large translucent panels, such as the Westcott 6x8-foot panel. If the child is seated on the grass in bright sun, the scrim can be held just overhead by two assistants. The panel would be positioned so that the child and the area just in front of and behind him/her is affected. If shooting at child-height, the background is unaffected by the use of the panel, but the lighting on the child is soft and directional. Usually, the diffusion panel softens the light so much that no fill source is required.

Fill Flash. In direct sunlight situations, set your flash at the same exposure as the daylight. The daylight will act as a background light and the flash, set to the same exposure, will act as a main light. If your exposure is $\frac{1}{250}$ second at f/8, for example, your flash output would be set to produce an f/8 on the subject. Use the flash in a reflector or diffuser of some type to focus the light. Position the flash to either side of the subject and elevate it to produce good facial modeling. An assistant or light stand will be called for in this lighting setup. If your strobe has a modeling light, its effect will be negated by the sunlight. Without a modeling light it's a good idea to check the lighting with a test frame and view the results on the LCD.

OVERHEAD LIGHT

Out in the open, mid-day sunlight has an overhead nature that can cause "raccoon eyes"—deep shadows in the eye sockets and under the nose and lower lip. The effects are also visible on cloudy days, although they can be tricky to see. If shooting under these circumstances, you have two choices. First, you can fill in the daylight with a reflector or flash. The amount of fill will determine the three-dimensionality of the rendering of the face(s) and effectively control "the personality" of the lighting. Second, you can find or create an obstruction to block the overhead lighting. The

best light for outdoor portraiture is often found in or near a clearing in the woods, where tall trees provide an overhang above the subjects. In an area like this, diffused light filters in from the sides, producing better modeling on the face. Man-made overhangs, like porches, can produce the same effect. You can also make your own overhang by having an assistant hold a gobo (an opaque or black reflector) over the child's head.

Reflectors. Whenever shooting outdoors, it is a good idea to carry along a large portable reflector. The larger it is, the more effective it will be. Portable light discs, reflectors made of fabric mounted on a flexible and collapsible frame, come in a variety of diameters and are very effective. They are available from a number of manufacturers and come in silver (for maximum fill output), white, gold foil (for a warming fill light), and black (for subtractive effects). With foil-type reflectors used close to

the subjects, you can sometimes even overpower the ambient light, creating a pleasing and flattering lighting pattern.

The fill reflector should be used close to the subject, just out of view of the camera lens. You will have to adjust it to create the right amount of fill-in, observing the lighting effects from the camera position. Be careful not to bounce light in from beneath the eye/nose axis; this is generally unflattering. Also, try to "focus" your reflectors (this really requires an assistant), so that you are only filling the shadows that need filling in. It helps to have an assistant or several light stands with clamps so that you can precisely set the reflectors.

Fill Flash. More reliable than reflectors for fill-in is electronic flash. For fill, many portrait photographers use barebulb flash, a portable unit with a vertical flash tube. This flash fires a full 360 degrees, so you can use wide-angle lenses without worrying about light falloff.

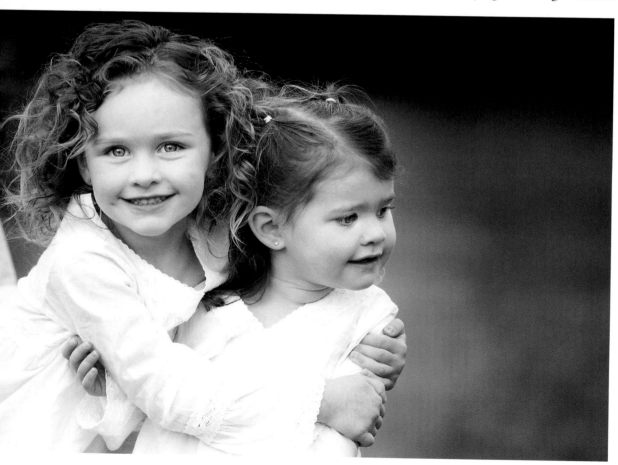

The effects of overhead lighting can be minimized by using a white or silver reflector in front of and beneath your subjects. Photograph by Prem Mukherjee.

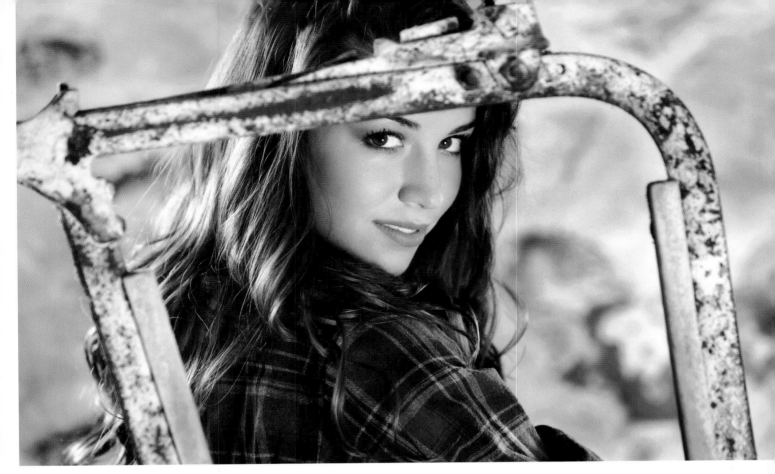

Fuzzy Duenkel created this image by harnessing the light streaming in from behind his senior through two windows. This light provided very nice hair and accent lights. The photograph was actually made in a barn. Fuzzy's homemade "FuzzyFlector" a stand-up, four-sided reflector, was used as the main light on the girl's face.

Barebulb flash produces sharp, sparkly light, which is too harsh for almost every type of photography except outdoor work. The trick is not to overpower the daylight.

You can also enhance the flash by placing a warming gel over the clear shield used to protect the flash tube and absorb UV. This will warm the facial lighting but not the rest of the scene. It's a beautiful effect. Other photographers like softened fill-flash. Robert Love, for example, uses a Lumedyne strobe inside a 24-inch softbox. The strobe is triggered cordlessly with a radio remote. He uses his flash at a 45-degree angle to his subject for a modeled fill-in, not unlike the effect you'd get working in the studio.

Another popular flash-fill system is on-camera TTL flash. Many on-camera TTL flash systems offer a mode that will balance the flash output to the ambient-light exposure. These systems are variable, allowing you to dial in full- or fractional-stop output adjustments for the desired ratio of ambient-to-fill illumina-

tion. They are marvelous systems and, more importantly, they are reliable and predictable. Some of these systems also allow you to use the flash off the camera with a TTL remote cord.

To determine your exposure with non-TTL flash fill, begin by metering the scene. It is best to use a handheld incident flashmeter in ambient mode, then point the hemisphere at the camera from the subject position. Let's say the metered exposure for the daylight is $1/15$ second at f/8. Now, with the meter in flash-only mode, meter just the flash. Your goal is for the output to be one stop less than the ambient exposure. Adjust the flash output or flash distance until your flash reading is f/5.6. Then, set the camera and lens to $1/15$ second at f/8.

When using fill flash, remember that you are balancing two light sources in one scene. The ambient light exposure will dictate the exposure on the background and the subject. The flash exposure affects only the subject.

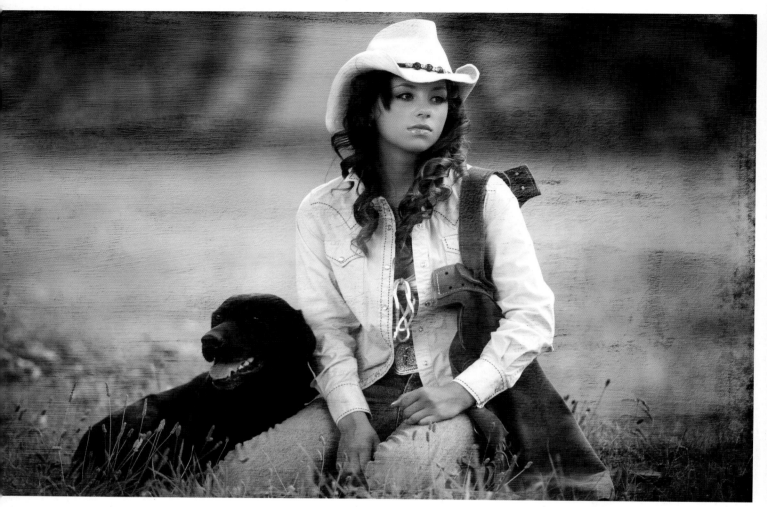

TWILIGHT

The best time of day for making great portraits is just after the sun has set. The sky becomes a huge softbox and the effect of the lighting on your subjects is soft and even with no harsh shadows. Because the setting sun illuminates the sky at a low angle, you have none of the problems of overhead light.

There are two problems, however, with working at twilight. One is that it's dim, so you will need to use medium to fast ISO speeds combined with slow shutter speeds. This can be problematic with children. Working in subdued light also forces you to use wide lens apertures, restricting the depth of field.

Another problem in working with twilight is that it does not produce catchlights in the subject's eyes. For this reason, most photogra-

ABOVE—Bruce Dorn made this image in a huge tree-lined pasture, which contained nothing but grass, a couple of curious horses, and an old settler's wagon. He saw the opportunity to use long-lens compression and using one of his safari lenses (the Canon 600mm f/4 IS) mounted to what he calls "a stout set of low sticks" (tripod). He was using a Quantum Qflash on an iDC Magic Slipper with a Pocket Wizard for sync, and was approximately sixty feet from the model. He continues, "The below-the-horizon sun illuminated the western sky to frame left. Between that sky and Kiersa's face was a line of trees that created scattered silhouettes. For a while, I shot with my 36x48-inch shallow softbox interposed between the girl and the hot sky. As the sky-canopy to the east darkened, the contrast increased to the point of distraction. I made a quick decision to deny nature and moved my softbox exactly opposite of the twilight sun. I then dialed my strobe's output to a very low setting and imagined it as my new setting sun. Now the afternoon sunlight seemed to be coming from the right-rear of the frame but the 'magic hour' sky assured that the face remained beautifully illuminated. It's all about balance." The image was finished with one of Maura Dutra's nifty textures.

FACING PAGE—Twilight is soft and not unlike a huge, warm-toned softbox in the sky. The lighting is nearly perfect in the moments just past sunset. Photograph by Michele Celentano.

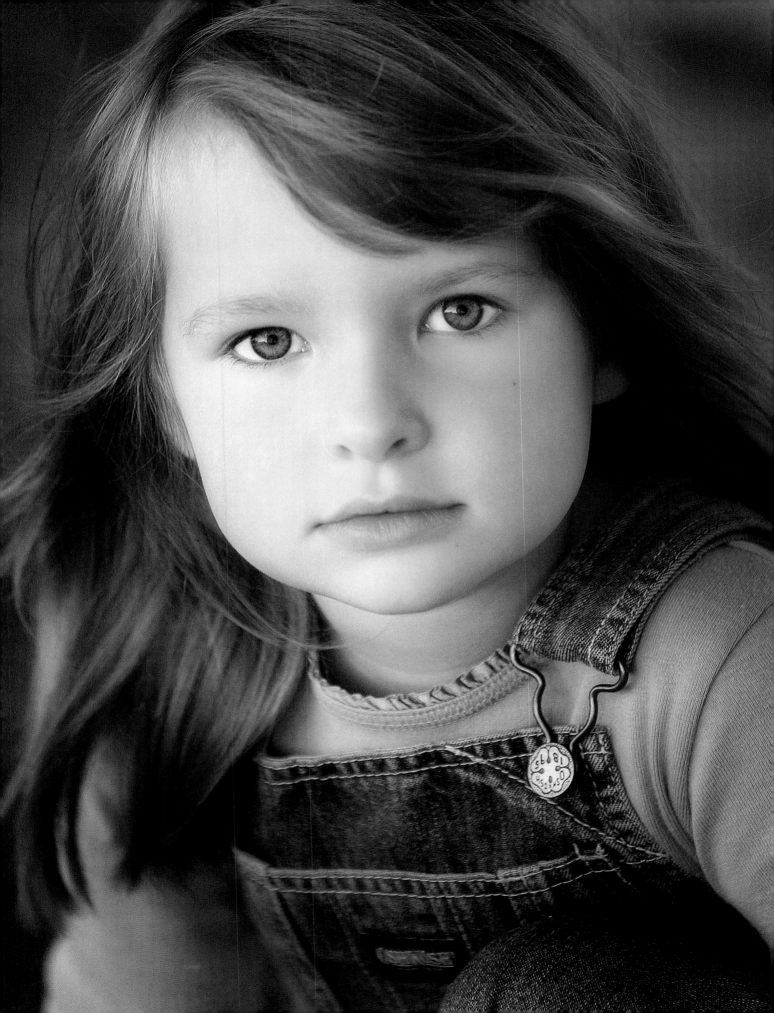

phers augment the twilight with some type of flash, either a barebulb flash or a softbox-mounted flash, which provides a catchlight and helps to freeze subject movement. (See Bruce Dorn's image on page 52.)

If the sky is brilliant in the scene and you want to shoot for optimal color saturation, you can use the flash to overpower the daylight exposure by up to one stop. This makes the flash the main light and lets the soft twi-light function as the fill light. The only problem with this is that you will get a separate set of shadows from the flash. This can be fine, however, since there aren't really prominent shadows from the twilight—but it is one of the side effects.

WINDOW LIGHT

One of the most beautiful types of lighting for children's portraits is window lighting. It is a

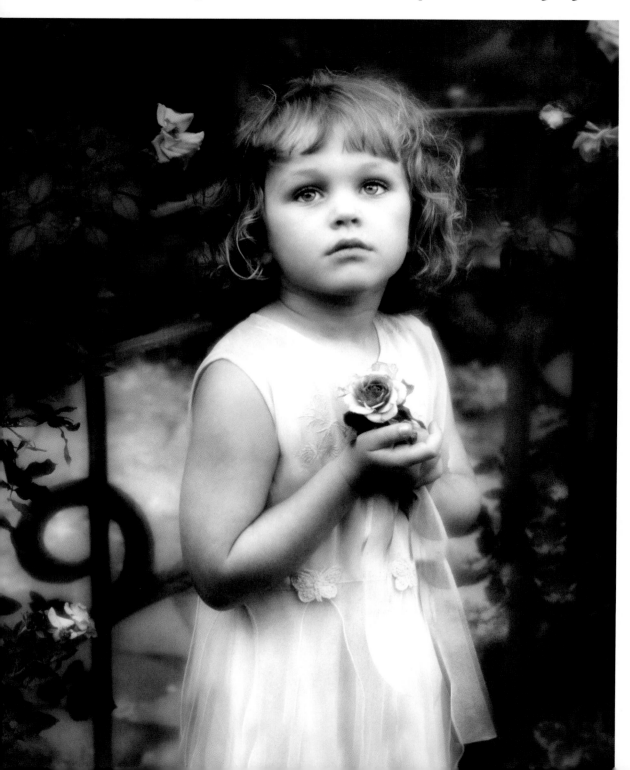

In this beautiful portrait by Kersti Malvre, the lighting is contrasty and overhead in nature. Kersti tilted her subject's head up to fill the shadows and diffused the image in Photoshop to lessen the lighting contrast.

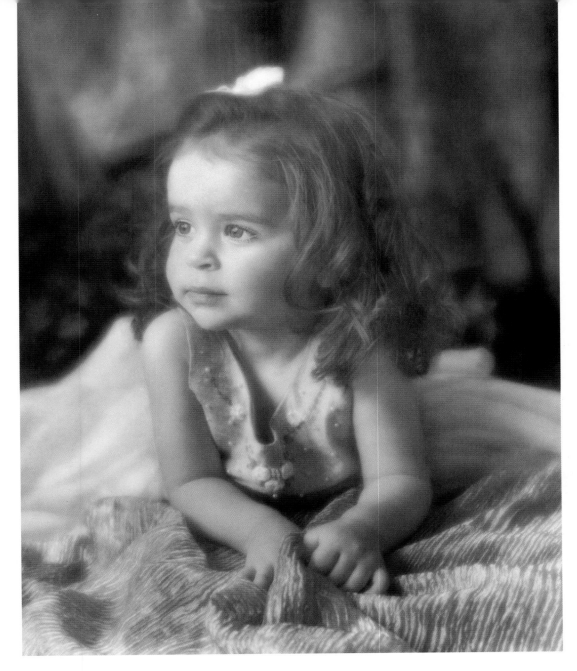

Window light can be beautiful. If the window is large enough—and the subject close enough to it—there will be ample wraparound lighting, as shown here. Photograph by Kersti Malvre.

soft, wraparound light that minimizes facial imperfections. Yet, it is also highly directional light, yielding excellent modeling with low to moderate contrast. Window light is fairly bright and it is infinitely variable. It changes almost by the minute, allowing you to depict a great variety of moods, depending on how far you position your subjects from the light.

Many children's photographers use a window seat in their studios. The windows, which wrap around the alcove of the window seat, produce a broad expanse of diffused daylight that is perfect for children's portraits.

Window Size. The larger the window or series of windows, the more the soft, delicate light envelopes the subject. Window light seems to make eyes sparkle exceptionally brightly, perhaps because of the size of the light source relative to the subject.

Falloff. Since daylight falls off rapidly once it enters a window—it is much weaker even just a few feet from the window—great care must be taken in determining the proper exposure for each portrait. You will need reflectors to kick light into the shadow side of the face. Have an assistant do this for you so you

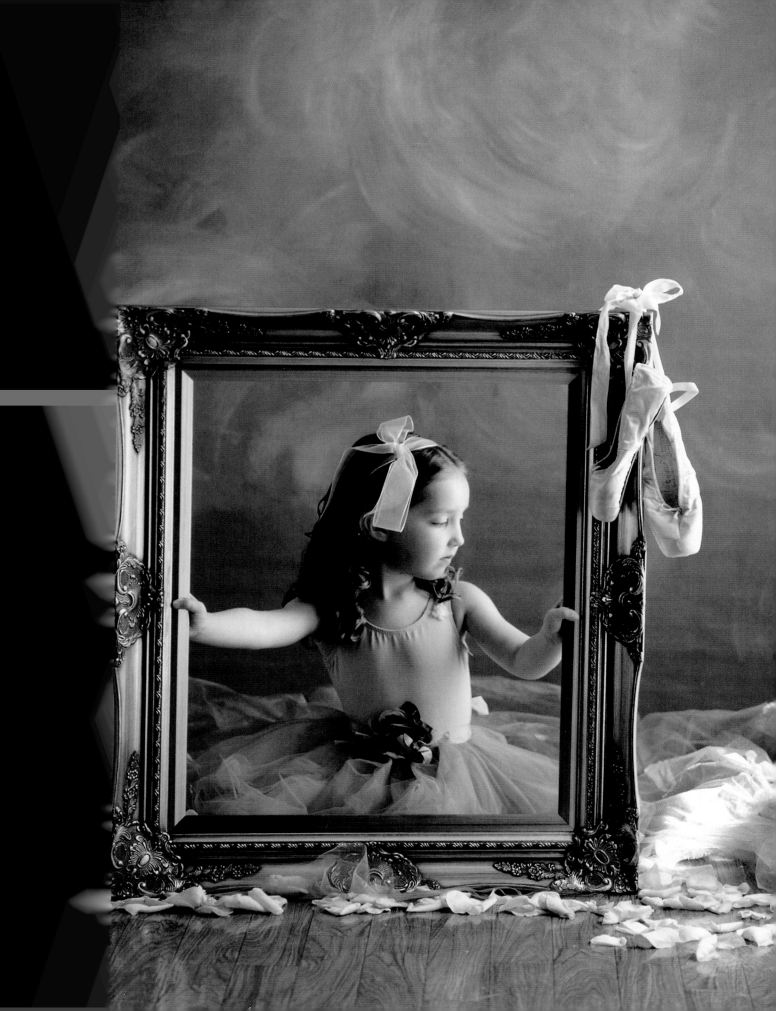

can observe the resulting lighting effects from the camera position.

Time of Day. The best quality window light is the soft light of mid-morning or mid-afternoon. Direct sunlight is difficult to work with because of its intensity and because it often creates shadows of the individual windowpanes on the subject.

Backlighting. Window light can also be used as a backlight with silver or gold reflectors employed to fill in the frontal planes of the face. This is a very popular strategy for children's portrait lighting—especially with translucent curtains hung in the windows for some diffusion. With this type of lighting, it is important to expose for the face and not the background of illuminated curtains. In some cases, the difference in exposure can be up to three stops.

Diffusing Window Light. If you find a nice location for a portrait but the light coming through the windows is direct sunlight, you can diffuse the window light by taping some acetate diffusing material to the window frame. Some photographers carry translucent plastic shower curtains with them just for this purpose. If the light is still too harsh, try doubling the thickness of the diffusion material.

A tool made specifically for diffusing window light is a translucent lighting panel, such as the 6x8-foot one made by Westcott. It is collapsible for portability but becomes rigid when extended and can be leaned into a window sill to create beautifully diffused light.

Light diffused in this manner has the warm feeling of sunlight but without the harsh shadows. Since this diffused light is so scattered, you may not need a fill source—unless working with a group of children. In that case, use reflectors to kick light back into the faces of those farthest from the window.

Fill Light. You can set up a white or silver card opposite the window and, depending on the distance to the window, the reflector may provide enough illumination on its own for adequate fill. If not, consider using bounce flash. While bounce flash may not be great as a primary light source for making children's

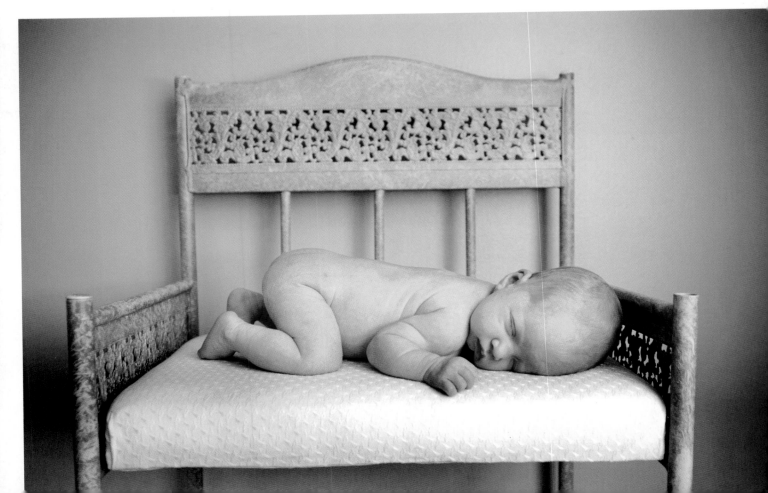

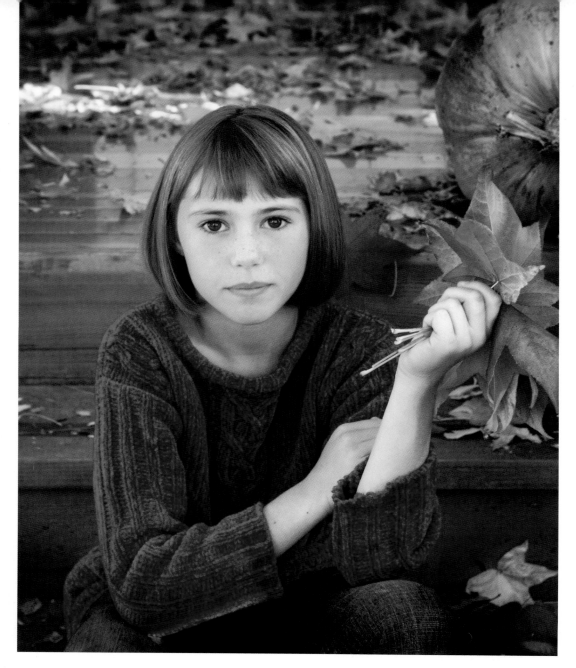

Most of the lighting refinements and intense coloration were done in Photoshop by the photographer, Kersti Malvre, who is a Photoshop wiz. The image history (viewable by going to File>Info when the file is saved as a PSD) shows extensive work in numerous layers for different parts of the image. For instance, the hair and leaves were extensively adjusted. The result appears natural, as if this were a found scene with lovely lighting, which was apparently not the case.

portraits, it is an ideal light source to supplement primary light sources like window light.

TTL flash metering systems read bounce flash very accurately, but factors such as ceiling distance, color, and absorption qualities can affect exposure. Although no exposure compensation is needed with these systems, operating distances will be reduced in bounce mode. Most camera-mounted flash units swivel so that you can bounce the flash off a side wall or even a reflector. These are ideal, since they will balance with your ambient light to provide the desired amount of fill-in.

In practice, you should meter the window light first and then set the bounce flash to produce $\frac{1}{3}$ to 1 full stop less light than the ambient-light reading. A test shot, verified on your camera's LCD screen, is the way to check that the bounce flash is effectively filling in the shadows.

Although this is a book concerning fine portraiture, there is really no point in going into the various formal posing rules and procedures used for adults; they simply don't apply. Even if a two-year-old could achieve proper head-and-neck axis, for example, the likelihood of him or her holding the pose for more than a nanosecond is slim. Additionally, since little ones are mostly non-verbal, posing instructions are completely ineffective. So then, how does one pose children—particularly small children?

MEETING THE CHILD FOR THE FIRST TIME

Experts say to never approach a child and start talking to them without first talking with the parent. Small children and babies take their cue from their mothers. They look to Mom to see if she sees the person as a friend or a threat. Photo studios are not known to children and they are unsure of the surroundings and their purpose. Experts also suggest not trying to be "friends" with the child. It puts too much pressure on them. Instead, show them some toys, letting the child know that these things are there for them to play with. Having your studio set up and ready to go is a great idea. Use a baby-sized doll to fine-tune your color and exposure, as well as your lighting. That

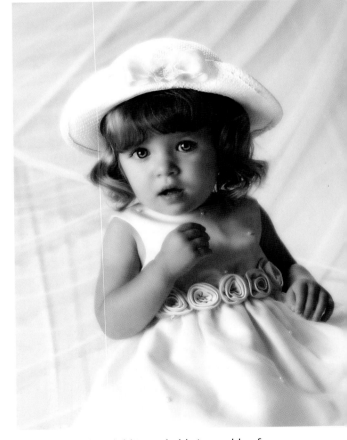

Even though this child is probably incapable of re-creating poses as instructed by the photographer, there are still posing options. The photographers, Jeff and Kathleen Hawkins, tilted the camera slightly to give the composition a dynamic diagonal line. The shoulders are already turned and the head axis is at a different angle. Hands are posed nicely for a child and the lighting is exquisite.

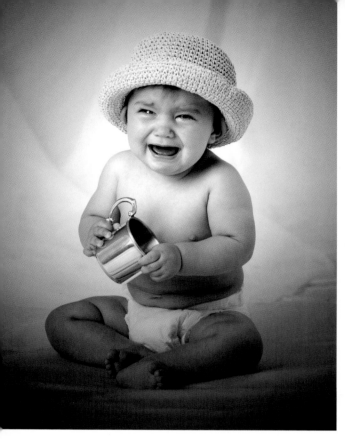

way, when the child arrives everything is ready to begin.

THE BASICS

Facial Analysis. The minute any good photographer meets a client, he begins to make mental notes as to which side of the face he wants to photograph, any irregularities (like one eye smaller than the other), facial shape (round, elliptical, elongated), color of the eyes (in older children), posture, and so on. The expert photographer will catalog these features and devise a strategy to light, pose, and photograph the child. Keep in mind that while most babies are blessed with flawless skin, their tresses may be a bit sparse at first. Also, depending on how the baby was born (*i.e.*, either natural childbirth or Caesarean), he or she may have an elliptically shaped head.

Use an Assistant. When photographing small children and babies, you really need to have an assistant. Whether the assistant is down at eye level with the child or behind the camera is strictly up to you—whatever works best. While one of you is distracting the child, the other can concentrate on the lighting, composition, and background.

Safety First. With small children or infants, safety is always the first consideration. A child who cannot sit up by himself cannot be propped up in a chair or left alone on posing blocks. Instead, the child should be positioned

LEFT—Photo studios are foreign places to children. They are uncomfortable at first but children usually warm to an environment with a pleasant atmosphere and plenty of toys. Even if that doesn't happen, the good children's photographer won't give up; sometimes a photo like this can be just as priceless as one that's all smiles. Photograph by Jeff and Kathleen Hawkins.

BELOW—If you think one small child can be difficult, try five. An assistant can be invaluable in such situations. While you deal with the technical details of the shot, the assistant can be working with the kids, getting them to relax and respond. This photograph by Alycia Alvarez worked out beautifully.

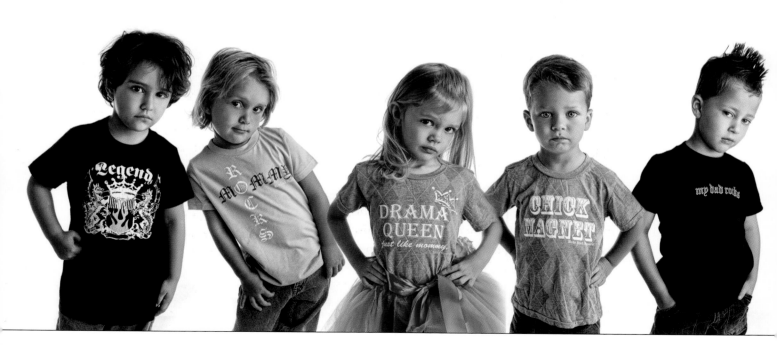

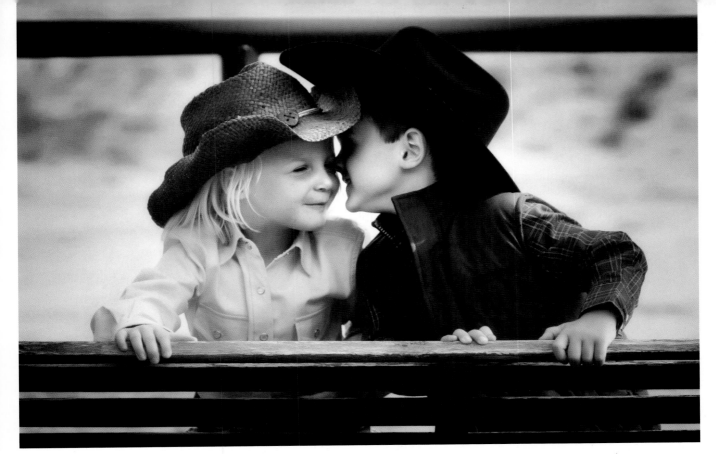

If kids are already involved in some fun activity, your job is to document their antics. Here, Kevin Jairaj did just that—and in a creative way. Notice the triangular composition and how the children are framed between the two long horizontal lines.

on the floor or ground, with pillows or other soft supports nearby. The child should never be left unattended, and it's best if the parent remains close by.

Put Mom or Dad to Work. Infants will sometimes stay put, but other times they will crawl off and have to be brought back. Having a parent close at hand makes things much easier, giving the baby some reassurance in a strange environment. It also helps the photographer evoke special emotions and expressions. The photographer can say to the child, "Look at Daddy, isn't he silly?" This is Dad's cue to act goofy or in some way amuse the child.

Do What Comes Naturally. It is important to let children do what comes naturally. Amuse them, be silly, offer them a toy or something that attracts their attention, but do so with a minimum of direction. Kids will become uncooperative if they feel they are being over-manipulated. Make a game out of it so that the child is as natural and comfortable as possible. Generate a smile, but don't ask them

to smile (if you do, you will probably not get what you want).

Camera Height. Be aware of perspective and its positive and negative effects when posing children. For a head-and-shoulders portrait, the camera should be at the child's nose height—too high and you will narrow the child's cheeks and chin; too low and you will

Use a Cable Release

Many children's photographers work with a camera on a tripod and a long cable release. This frees them from the camera position, allowing better interaction with the child. In such situations, the composition must be a bit loose in case the child moves. When focusing, observe the child's movement to get an idea of where your focus point should be and how far your depth of field extends within the scene. Take your best estimate on focus and ensure that you'll have enough depth of field, even if the child moves, to get a sharp image.

distort the shape of his/her head. For three-quarter length and full-length poses, the camera height (especially with shorter focal lengths) should be midway between the top and bottom of the areas of the child's body to be shown in the frame.

Keeping the camera at the same level as the baby also helps you relate to the child on his or her own level. Psychologically, this is im-portant. Instead of leering over a small child with strange and unfamiliar equipment and funny-looking lights, you are putting yourself "on the same level" as the child.

Touching. Sometimes, no matter how simply you explain what you want the child to do, he or she just won't understand your instructions. The best way to remedy the situation is to gently touch the child and move the errant

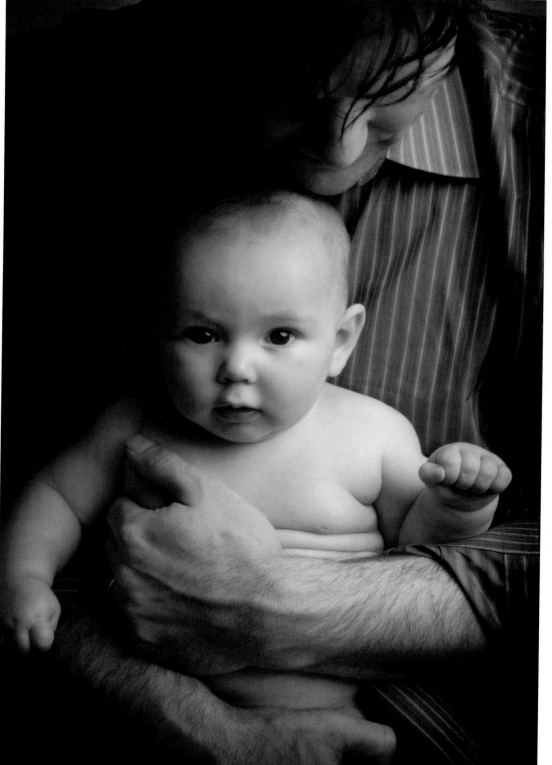

LEFT—In this wonderful portrait of father and baby, photographer Jim Garner chose to position the height of the camera closer to the father's head height so that you are really looking down on the baby. The elevated view helps to frame the baby amidst the dad's chin and his massive hands. The baby is being held safely in his father's grasp.

FACING PAGE—Brian Shindle makes exquisite portraits of children, sparing no expense and not overlooking a single detail. The beaded dress is captured elegantly with dual softbox lighting. The little girl is almost head-on to the camera, but her extended right arm gives a beautiful base to the composition as well as displaying the very expensive dress. Her expression is quizzical and not unlike that of the Mona Lisa. The orange floral display adds a beautiful counterpoint to the rest of the warm-toned portrait. Notice that the child has no shoes on. Shoes can date a photograph more than any other article of clothing or hair style.

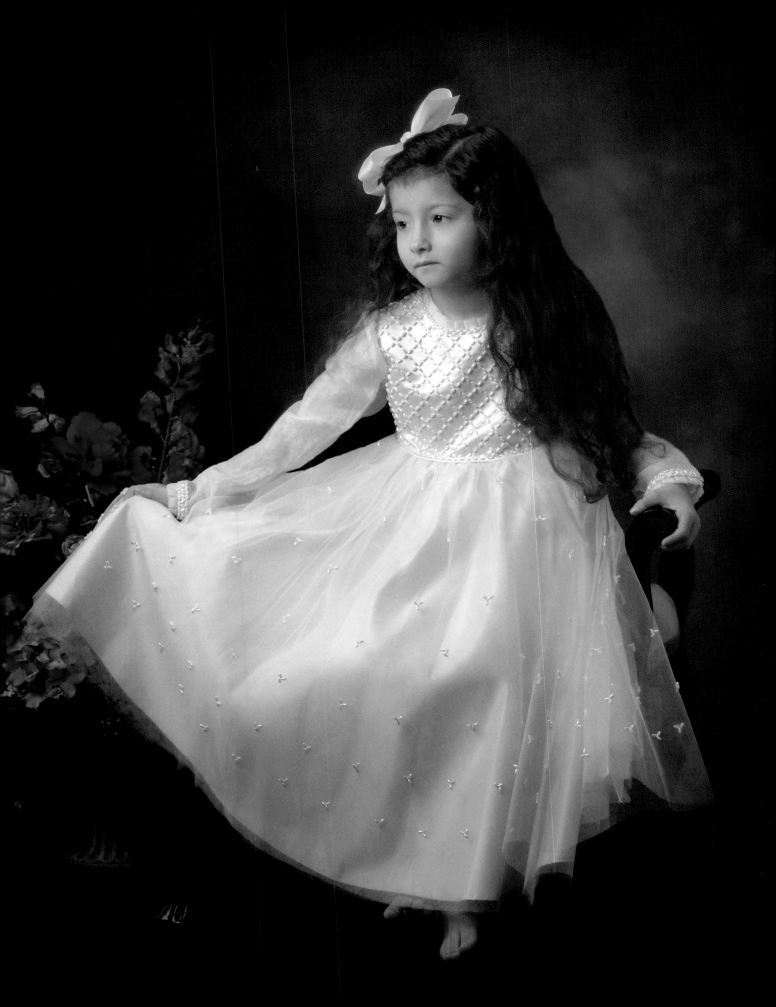

curl or slide them over just a bit on the posing block—whatever the needed correction happens to be. Be advised that touching can be intimidating to children, particularly since you are a stranger. Always ask first and then be gentle and explain what you are doing. If the child is shy, have Mom or Dad move the child per your directions.

Work Quickly. With kids, especially small children, you don't have much time to work, so be sure your lights and background are roughly set before bringing the child into the studio or into the area where you're going to make the photograph. You have about thirty minutes in which to work before the child gets tired or bored or both. This is another reason to have an assistant who can hand you a new memory card, adjust a light, or the fold of a blanket without you having to move from the camera position. Always be ready to make a picture; children's expressions are often fleeting. That said, you cannot rush a good portrait. Be prepared to spend some time laying the groundwork—gaining the child's confidence and letting him (or her) acclimate to the strange surroundings.

THE FACE

Head Positions. There are three basic face positions in portraiture. They dictate how much of the face is seen by the camera. With all three of these head poses, the shoulders should remain at an angle to the camera. These views are easily accomplished even with small children. Their attention can be diverted to get them to look in the direction that adds the right dynamics to the pose. Alternately, you can prearrange the posing furniture at the precise angle you want to the camera lens.

Seven-Eighths View. The seven-eighths view is when the subject is looking slightly away from the camera. From the camera position, you see slightly more of one side of the face than the other. You will still see the subject's far ear with this pose.

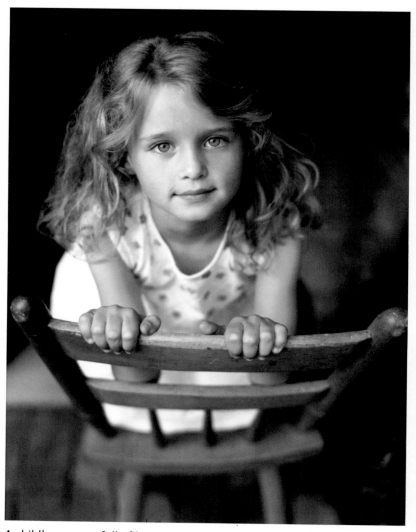

A child's eyes are full of honesty and genuine personality. Little kids are incapable of guile, so what you see reflected in their eyes is true self. Janet Baker Richardson captured this beautiful young girl in a relaxed, happy moment. Janet wanted only the face and hands sharp so she photographed the girl with the lens wide open with a relatively fast shutter speed by existing daylight.

Three-Quarter View. With a three-quarter view, the subject's far ear is hidden from the camera and more of one side of the face is visible. The far eye will appear smaller because it is naturally farther away from the camera than the near eye.

It is, therefore, important when posing the child in this view to position the subject so that their smaller eye (people usually have one eye that is slightly smaller than the other) is closest to the camera, thus using perspective to make the eyes appear to be equal in size when viewed in the final portrait.

Profile. In the profile view, the subject's head is turned almost 90 degrees to the camera. Only one eye is visible. When posing a child in profile, have your assistant direct the child's attention gradually away from camera position. When the eyelashes from the far eye disappear, your subject is in profile.

If you look closely in the pupil of the baby's eye, you can see mom, down on her hands and knees at eye level with the baby, getting his attention. The photographer, Jim Garner, chose to work from the side to catch an almost profile view, but the eyes are full of wonder thanks to mom's antics outside the frame.

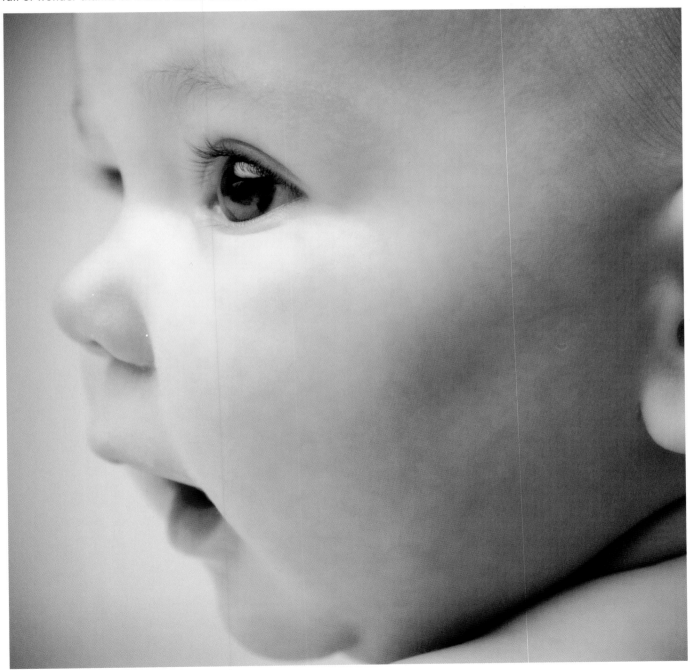

Teens like unusual, edgy posing. It's a form of self-expression and one of the things that makes senior photography so interesting to the photographer. Although this image breaks a lot of the "formal" posing rules, it is still a hit in the senior world. Photograph by Nick Adams.

Tilting the Head. The tilt of the head is physically complex. There are only two ways to tilt the child's head: toward the near shoulder or toward the far shoulder. Which way depends on the composition and lighting. You can ask your assistant to tilt his or her head slightly and ask the child, "Can you do this?" but usually you will get an exaggerated version of the pose. Although difficult to achieve, this posing point introduces yet another dynamic line into the composition.

The Eyes. A child's eyes reflect all of the innocence and vulnerability that are the essence of childhood. For this reason, it is imperative that the eyes be a focal point of any children's portrait.

The best way to keep the child's eyes active and alive is to engage him or her in conversation or a game of some type. If the child does not look at you when you are talking, he or she is either uncomfortable or shy. In extreme cases you should let Mom do all of the enticing. Her voice is soothing to the child and will elicit a positive expression.

The direction in which the child is looking is important. Start by having the child look at you. Using a cable release with the camera tripod-mounted forces you to become the host and allows you to physically hold the child's gaze. The basic rule of thumb is that you want the eyes to follow the line of the nose. When your assistant holds an object for the child to see, have him or her move it back and forth, so that the eyes follow the object.

The colored part of the eye, the iris, should border the eyelids. In other words, there should not be a white space between the top or bottom of the iris and the eyelid. If there is a space, redirect the child's gaze.

A stack of four white towels made the perfect posing block for this baby. Notice how well the child's arms, legs, and feet and hands are positioned. The baby is comfortable in such a setting and quite at home in front of the camera. Photograph by Deborah Lynn Ferro.

Pupil size is also important. If working under bright modeling lights (strobes are recommended over incandescent lights because of the heat factor), the pupils will contract. A way to correct this is to lessen the intensity of the modeling lights. You can always increase the intensity to check the lighting pattern and quality. Just the opposite can happen if you are working in subdued light; the pupils will appear too large, giving the child a vacant look.

Expressions. Kids will usually mimic your mood. If you want a soft, sweet expression, get it by speaking in soft, quiet tones. If you want a big smile, bring the enthusiasm level up a few notches.

Above all, be enthusiastic about taking the portrait. The more they see how fun and important this is to you, the more seriously the child will take the challenge. After a few frames, tell them how great they look and let them know how things are going. Like all people, children love to be told they are doing a good job.

Never tell children to smile. Instead, ask them to repeat a funny word or ask them their favorite flavor of ice cream. And don't be afraid to create a more serious portrait—the best expressions aren't just the big smiles. A mix of portraits, a few with smiles and some showing the child's gentler side, is usually appealing to parents.

THE BODY

First and foremost, do not photograph a child (or adult) head-on with their shoulders square to the camera. This is the mug-shot type of pose and, while it is acceptable in close-up portraits, it is generally not recommended. The shoulders should be at an angle to the camera. This is easily accomplished by arranging any posing stools, chairs, or blocks on an angle to the camera. Then, when the child is put into the scene, the shoulders are already turned. This technique introduces a visually pleasing diagonal line into the composition.

The Head-and-Shoulders Axis. Step two, which is often a function of luck with children, is to turn the head to a slightly different angle than the shoulders, introducing a second dynamic line in the composition. In male portraiture, the head is traditionally turned the same direction as the shoulders; with women, the head is usually turned to an opposing angle. The only reason this is mentioned is so that you are aware of the difference.

You can often redirect the line of the child's head by having your assistant hold up something interesting within eyesight of the child, then move it in the direction that turns the child's head slightly. By turning the shoulders and face slightly away from the camera, you allow the frontal planes of the face to be better defined with light and shadow.

Arms and Hands. Regardless of how much of the child is visible (*i.e.*, whether it is a head-and-shoulders, three-quarter-, or full-length portrait), the arms should not slump to the child's sides. Often, giving the child something to hold will encourage them to raise their hands to more closely inspect the object. This creates a bend in the elbows and introduces more dynamic lines into the composition. Not only are a child's hands interesting, but having them visible means that the elbows are bent, thus providing a triangular base to the composition, which attracts the viewer's eye upward, toward the child's face.

A child's hands are delicate and beautiful and should be included whenever possible. While it is basically impossible to pose children's hands—other than by giving them something to hold—you can gain some control by varying the subject distance and focal length. If using a short focal length lens, for

Marcus Bell chose to photograph this baby in a full-length pose, revealing all of the beauty and character of the child. Marcus photographed the child with a large softbox close to the floor, where the baby was posed. He wanted the entire child sharp, so he chose an angle that would capture the sharpness from his nose to his toes. In digital printing, Marcus darkened the legs and torso so that the face would be prominent, but left these areas open enough to see the beautiful detail throughout. This is a classic children's portrait.

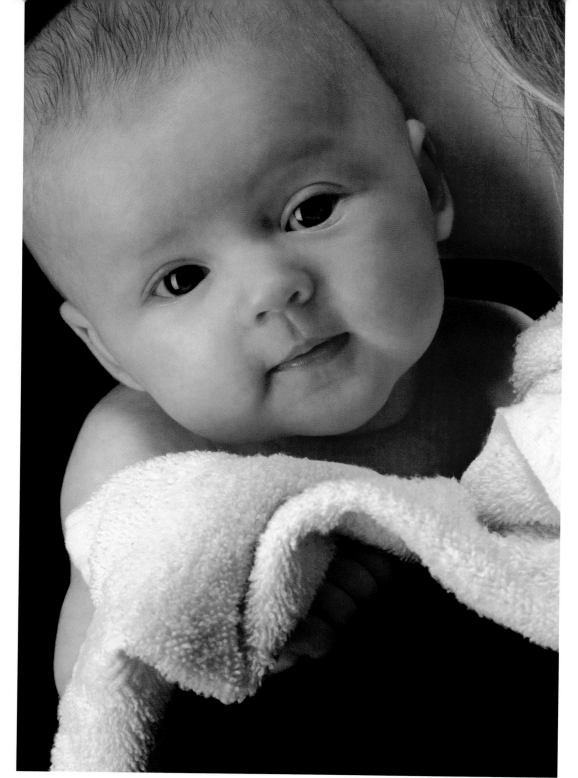

example, hands will be close to the camera and appear larger than normal. Using a slightly longer-than-normal focal length sacrifices the intimacy of working close to the child, but corrects the perspective. Although holding the focus on both the hands and face is more difficult with a longer lens, the size relationship between them will appear more natural. And if the hands are slightly out of focus, it is not as crucial as when the eyes or face are soft.

While the vast majority of hand poses are not particularly useful to this discussion, it should be noted that the most flattering results are obtained when the edge of the hand

is photographed, as hands pointing straight into the lens appear "stumpy." Also, where possible, fingers should be photographed with slight separation. While it is impractical to do much about hands with children, it is useful information to know.

THREE-QUARTER- AND FULL-LENGTH POSES

Where children are concerned, the difference between three-quarter length and full-length poses is slight. There are a few things you should keep in mind, however.

A three-quarter-length portrait is one that shows the subject from the head down to a region below the waist. This type of portrait is best composed by having the bottom of the picture be mid-thigh or mid-calf. You should never "break" the composition at a joint—at the ankles, knees, or elbows. It can be visually disquieting.

A full-length portrait shows the subject from head to toe. This type of portrait can be made standing or sitting, but it is important to remember to angle the child to the lens or adjust your camera position so that you are photographing the child from a slight angle. The feet, ordinarily, should not be pointing into the lens.

When the child is standing, hands become a real problem. If you are photographing a boy, have him stuff his hands in his pockets— it's an endearing pose. You can also have him

fold his arms, although children sometimes adopt a defiant stance in this pose. With a little girl, have her put one hand on her hip, making sure you can see her fingers. Full-size chairs make ideal props for standing children because the child's hands can easily be posed on the arm of the chair or along the chair back.

When a small child is sitting, have them curl one leg under the other. This makes them into a human tripod—very stable and upright. Children are comfortable in this pose and have the full use of both hands so that they can hold or play with any toy or a prop you may have given them. Best of all, they usually don't wander off from this pose unless they're very active.

POSING TIPS BY AGE

Newborns. Newborns are usually not very alert at any time during the day. They sleep and barely eat for the first few days, sometimes weeks, after birth. Ideally, a session should be scheduled to begin about the same time as a scheduled feeding. It's a good idea for Mom to feed the baby at the studio just prior to the session beginning.

Babies. Babies, particularly at early stages in their development, are inseparable from their mothers. What happens when you want to "remove" baby from Mom to make the portrait? Baby will not normally react well. To avoid this situation, you can make some beautiful close-up portraits of the baby without Mom ever having to hand the child over. For example, you can have Mom lie down on the

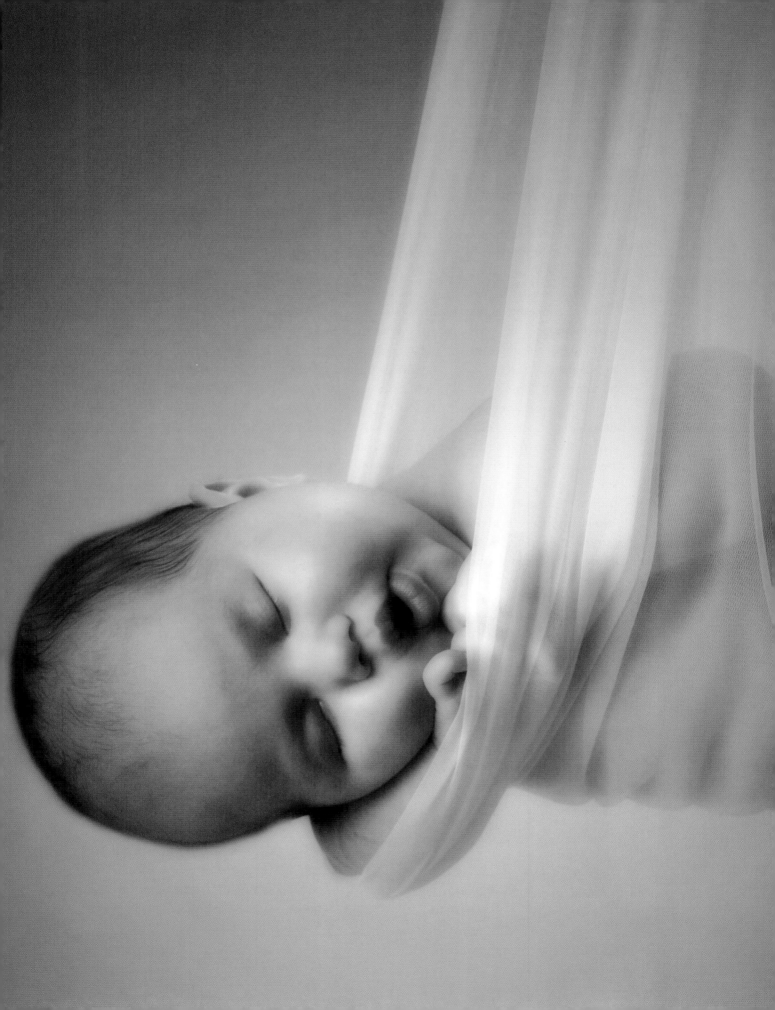

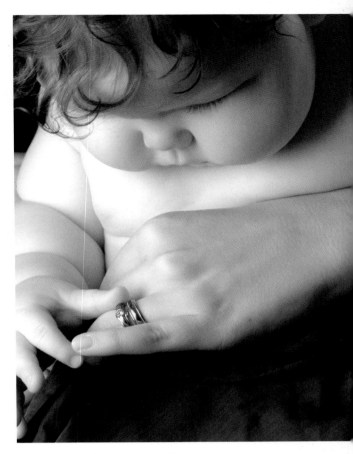

floor with the baby next to her. There is no feeling of detachment since Mom is nearby (just position the mother slightly out of frame). Most moms can rest the baby on one hip, then lean away to give you a clear vantage point for a head-and-shoulders portrait of the baby, who will be very happy to be with his or her mother. There are many variations of this pose and, since the baby will move wherever you tell the mother to move, you can pose the child with precision. Try to include the baby's hands in the photo, which can be easily done by giving the child something interesting to hold on to. Hands more completely define a baby portrait.

Tummy shots are a favorite with young babies. You should bear in mind that one physical activity is about all they can handle, so a secondary physical activity, like smiling, might be impossible as the baby tries to keep his or her head up. They may smile if amused, but usually their heads will drop down at the same time.

Baby Posers. To help a baby hold his head up while lying on his tummy, you can buy U-shaped baby posers, found at all retail baby stores. They can be covered with fabric. Place the baby face forward with his feet dropped down lower than his head. Position your camera lower than the baby's head. This way the baby does not need to lift his head as much to see you, which will prevent him from getting fatigued.

Up Close. Babies produce an extraordinary range of expressions. By zooming in with an 80–200mm zoom lens, you can fill the frame with the baby's face and—if he or she is not being too wiggly—elicit a dozen completely different facial expressions. A series like this makes a beautiful sequence or montage. Be careful not to loom over the baby with too short a focal-length lens, or you will look like a Cyclops to him!

Six- to Eleven-Month-Olds. Parents usually choose the six-month date to have baby's first formal picture done. If possible, arrange to do it at the end of the sixth month—more like the seventh month. Babies at this age are getting the hang of things. They are social and happy and not fully mobile, making your job easier. Most are happy to sit and play without wanting to crawl away, making the session a breeze.

Two-Year-Olds. When two-year-olds are involved, even the best laid plans rarely work out. You have to be flexible and open.

Burp Cloths

Burp cloths can be very useful at a baby photo session. In addition to their intended purpose, they can be used to rub a teething baby's gums in a fun way that will produce pleasing results. Also, since babies tend to drool all the time, you can capture big reservoirs of drool that are waiting to come out when the baby smiles.

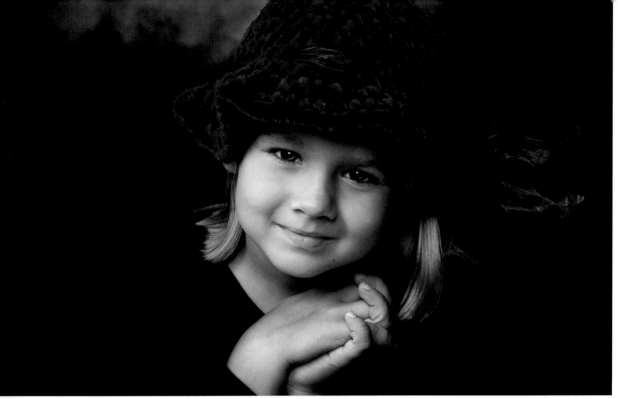

Like adult portraits, kids' portraits should be well posed. Deborah Ferro had this young girl grasp her hands and place them under her chin. She posed the hands so the edges were showing and made sure they were darker than the girl's face in the final portrait

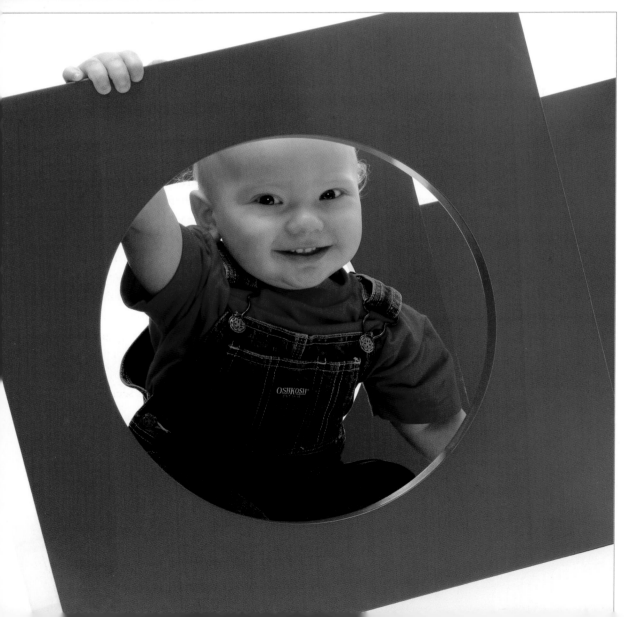

A bright red climbing box is the perfect environment for this toddler. He is perfectly happy exercising his control over the space. Photograph by Deborah Lynn Ferro.

Don't compose an overly tight set in which to photograph the child. Two-year-olds will do whatever they want. They are experiencing mobility (walking around) and the beginnings of speech (getting what they want by asking for it), and this leads to an independence that causes them to be known as "terrible twos." A loosely structured set in which they have some mobility (or better yet, an outdoor scene where they have a lot of mobility) is recommended. You can, of course, with good communication and patience, direct the headstrong two-year-old—but not for long.

When working with two-year-olds, it is best to handhold the camera and follow them as they move around. This will often require shooting a lot of frames and it may inhibit your lighting setup. Available light is often best with these active subjects.

Older Children. With older children, the best way to elicit a natural pose is simply to talk to them. Many kids are uninhibited and will talk to you about anything under the sun. Good topics involve your surroundings, especially if you are working outdoors. Or you can talk about them—their interests, brothers and sisters, pets, and so on. While it is not necessary to talk all the time, be aware that silence can be a mood killer and may lead to self-consciousness. Try to pace the conversation so that you are both engaging and yet free to set up the technical details of the photo.

Kids also like being treated as equals. They don't like being talked down to and they value the truth. Be honest about what you expect of the child and get them involved in the process of making the picture. You might even try asking them how *they* would like to be photographed; kids like to be asked their opinion and they might just come up with a great idea.

With children, it is a good idea to size up personalities, just as you would with an adult. A good plan is to ask children about their favorite thing to do, then watch how they react when they start to think about it. If a child is on the quiet side, any kind of wild, exaggerated behavior might send him screaming. In this case, try a quiet story and some low-key talking. With very shy children, you may even have to stay in the background and let the parent direct their child, following your instructions. In these situations, you might want to use a longer lens and back off so that you are not part of the interaction.

Well-known portrait photographer Frank Frost thinks that kids are too sharp to have anything pulled over on them. Before he starts a photo session, Frost gets down on the floor and visits with the child. He always uses an assistant, noting that he doesn't see how it's possible to get great expressions from children and babies *and* handle all of the technical details and posing. His assistant hams it up with the child while Frost readies the lights and camera. To make his studio a place children want to return to, he keeps a small toy box in the studio, which children always seem to remember fondly.

POSING AIDS

Posing Steps. Many children's photographers maintain several sets of portable posing steps or blocks that can be used individually or in

Mimicking

A sure-fire hit is to mimic the baby's noises. Just like a mockingbird will emulate your whistle, so the baby will be delighted that you can make the sound that they can make. To them, it's communication. This creates smiles and more smiles.

A Breeze

Most small children take delight in a breeze. When babies feel a breeze outdoors, you can see their eyes narrow and they smile with delight; it is a very pleasurable moment. In the studio, substitute a piece of foam board from a few feet away. Wave it briskly so that it creates an unanticipated breeze. It can be a mood changer.

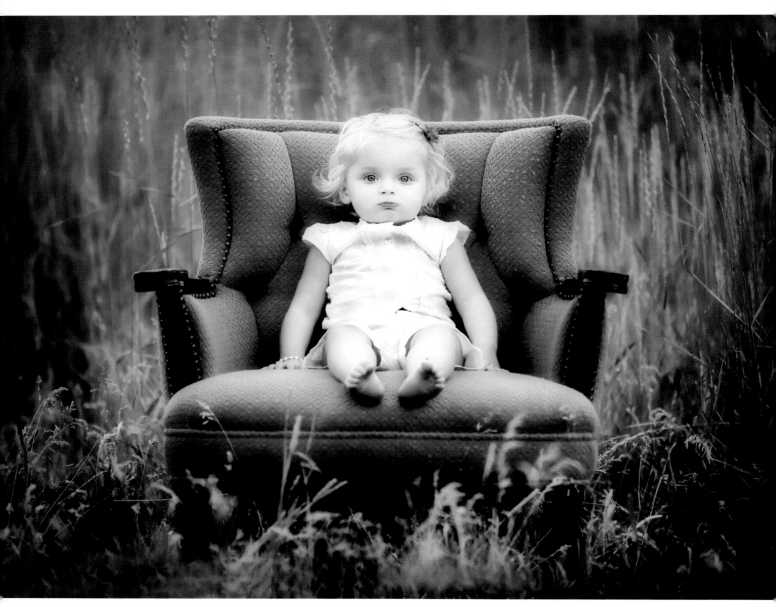

tandem for several children. These items are usually made of wood and can be draped with fabric, such as crushable backgrounds. Steps or blocks provide good support and are safe for toddlers to crawl up on. They also work well for photographing more than one child at a time because they instantly get the subjects' faces on different levels—which is a must for good composition.

Drape and position these items before the child arrives so that, once the lighting is set, you can bring the child over and he or she will sit naturally and fall into a normal, believable pose. One of the great advantages of using posing blocks in the studio is that they are large enough to conceal a background light placed behind them.

Chairs. Small children may often do better when "contained." For this reason, little chairs make great posing devices. Place a tiny pillow in the chair and then have Mom place the child in the chair. When all is set, cue Mom to call the child by name.

Another good trick is to place a small chair down on the set. Then, take turns with the child's mother and even your assistant sitting on it. Since it's a small chair with a large person sitting on it, it's funny to a small child—

Nichole Van Valkenburgh is very fond of this chair as a prop and takes it with her on location for many of her children's portraits.

like something is really out of place. At this point, you won't even have to ask the child if she'd like to sit in it. She'll assume it's for her because of its size and because all these other people want to sit on it. In fact, she'll be pretty sure she wants to occupy it for some time.

Adult-size chairs are also effective posing tools. The chair should be stable and visually interesting. A great pose is to have a child standing in the chair, holding onto the chair back and looking back over a shoulder at the camera. Have a parent or assistant nearby in case the child gets too adventurous. Antique stuffed or velvet chairs work beautifully for this kind of photo. (*Note:* If all else fails, challenge the child to scramble up into the chair—or find a box and challenge them to climb up out of it.)

Patti Andre, who specializes in custom storybook albums of kids, is also great at activity-based poses. This image is called *Kiss Poster.* The image was photographed in RAW mode and the white balance adjusted to a very warm tint in RAW file processing. The exposure was also adjusted in RAW mode to create a high-key effect. The image was made on a Canon EOS 1DS with an EF 85mm f/1.2 lens.

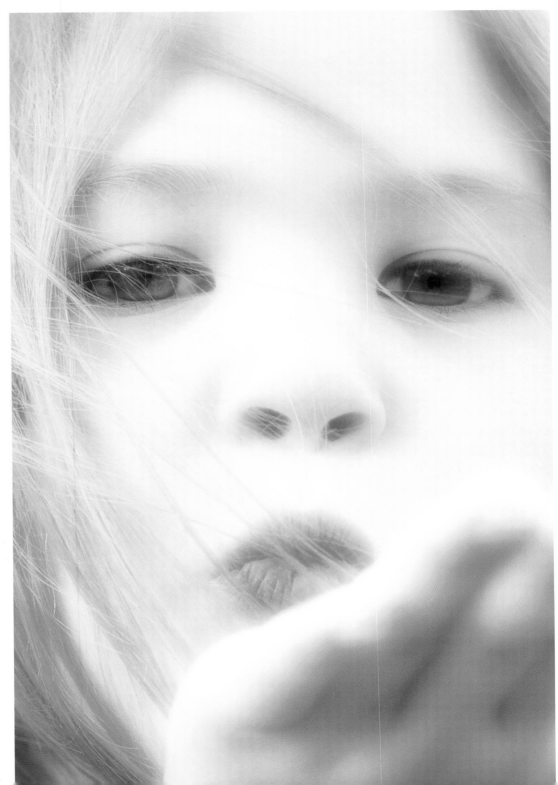

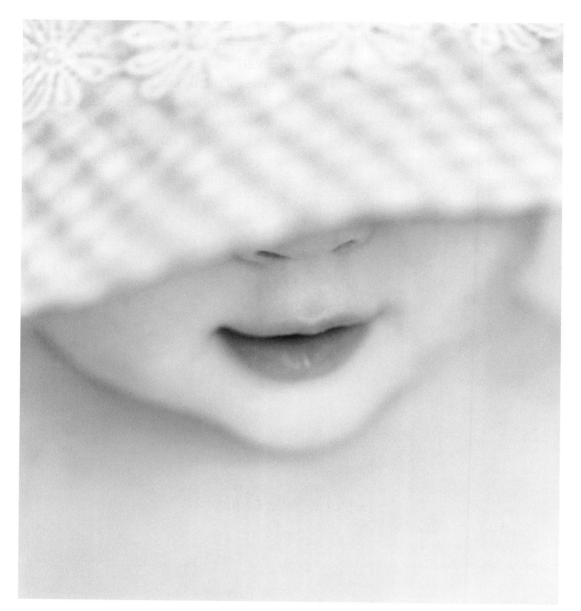

Isolating details, either zooming in or cropping in tighter on an image, eliminates unwanted and often unnecessary details in the image. In this lovely image, children's portrait artist Suzette Nesire featured a very large face size by eliminating everything but the hat and part of the baby's face.

ACTIVITY-CENTERED POSES

Where little ones are concerned, posing really means maneuvering the child into a position in which he or she appears normal and natural. Little children react most positively to the concept of "activity-centered" portraits. In a typical shooting session, the assistant gets down on the ground with the child, just out of view of the camera. A full complement of props is on hand, including a bubble bottle and wand, a long feather, a squeaker, and a storybook or two. When the photographer decides the lighting and other technical details are right, the assistant will begin to coax and entertain the child. A long feather is a big hit and a great icebreaker. The feather provides both visual and tactile stimulation. Most children are fascinated and their expressions might range from curiosity to glee.

PROPS AND GAMES

Most children's photographers have a collection of props and toys for kids to play with. Mothers will probably bring a few of the child's favorite things, too—a stuffed animal or a rattle or some other prized possession—and these can be used to attract and distract. Encourage parents to bring along items that

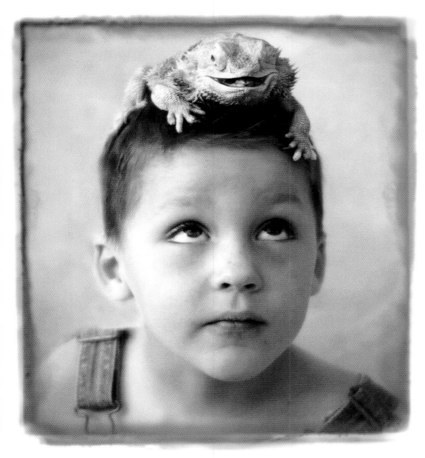

When you are photographing a child and his pet, very little needs to be done to elicit priceless expressions. The image was softened and given a unique edge treatment in Photoshop. Photograph by Kersti Malvre.

will make the child feel comfortable and at home. This is usually not a problem with small children, as they tend to travel with their favorite blanket or stuffed animal. Often, a few flowers make wonderful props, since small children are always fascinated by the color and shapes of flowers and enjoy holding something. Flowers can also add a little color to spice up your composition.

Usually it takes more than a prop to engage a child for the length of the photo session. Playing "make believe" is a good option. Kids have a natural inquisitiveness that is easily tapped. Just start a sentence, "Imagine you're a . . ." Fill in the blank and you'll immediately see their imagination kick in!

Sometimes you just need to be silly with kids. Talk about your pet rhinoceros, or your other car, which is pink and yellow with purple seats. One photographer I know likes to ask kids, "Are you married?" which always gets a good chuckle. Playing peek-a-boo is another

favorite—hide behind the camera and peek out from either side. The child will burst into laughter!

Overstimulation. All children need some stimulation to get good expressions, but a good assistant knows how to avoid overstimulating the child. Where this line in the sand falls depends on the age of the child. Because their attention span is so short, younger children need quite lot of stimulation—talking, imagining, being silly, making noise, etc. The same level of stimulation that keeps a one-year-old happy, however, will overstimulate an older child. This may end the session prematurely.

The Bribe. When it's getting toward the end of the session, many photographers use a bribe to keep the child interested for just a few more shots. Others use a reward system, giving the child a coloring book or other small gift for being such a good subject. One well known children's photographer offers cookies midway through a session as a means of keeping a little one's interest. (*Note:* It is important to get permission from a parent before doling out food!)

The Tickle Feather

The ultimate baby photographer's prop is the stick with funny feathers on it. It works for almost all age groups. For very young children, its colors can be used as a focusing device. To a child who can sit up, it becomes more useful and fun. It's a good idea to introduce the feather by showing it to Mom first. She can then introduce it to the baby. If Mom likes it, baby will be less likely to be scared. (By the way, these things really do tickle, especially when rubbed across bare feet or under the chin.)

For one- to three-year-olds, it's sometimes fun to use the feathers to tickle Mom. You can ask them, "Would you like me to tickle Mommy?" Most of the time, this is absolutely hilarious to a young child.

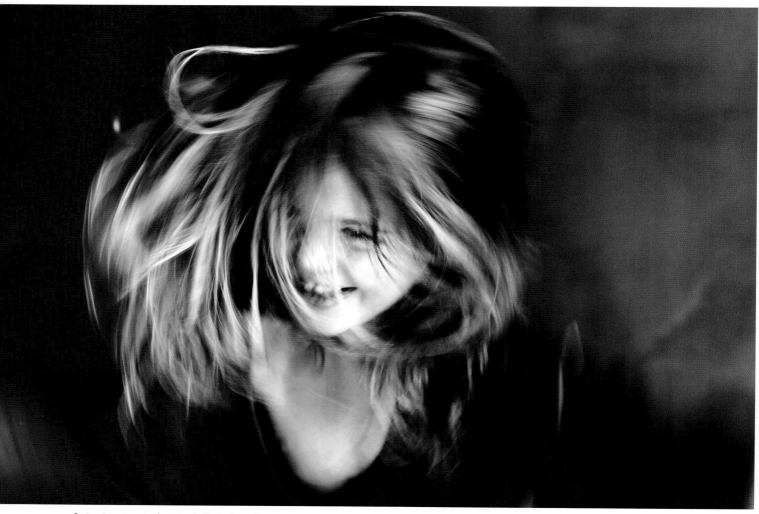

Spinning in circles is definitely a fun game, no matter how old the child. This wonderful portrait of Vanessa by Patti Andre captures the sheer joy of the activity. Patti used a moderately slow shutter speed of $\frac{1}{60}$ second and a moderate ISO setting of 200 in order to capture some blur in the image.

If a small child hates to be on his tummy and won't do anything but cry, try putting a tiny dot of sugar on the end of his tongue. This will distract him and perhaps change the behavior. This technique works about half the time with toddlers, but it works most of the time with two-year olds. Don't use sugar during a photo session until it's absolutely necessary, as there is no going back. Sweets will make you the child's best friend, but once they've received a treat, kids can become quite demanding—especially if they are naturally willful or feeling tired.

Composition in portraiture is no more than good subject placement within the frame. There are several schools of thought on proper subject placement, and no one school offers the only answer.

THE RULE OF THIRDS

One of the basics in image composition is the Rule of Thirds. According to this rule, the rectangular viewing area is cut into nine separate squares by four lines (like a tic-tac-toe grid). In this grid, the points where any two lines intersect is considered an area of dynamic visual interest. These are ideal spots to position the main subjects in the group.

The subject of the composition does not necessarily have to be placed at an intersection of two lines; he or she could also be placed anywhere along one of the dividing lines. In head-and-shoulders portraits the eyes are the region of central interest, so it is a good idea if the eyes are placed on a dividing line or at the intersection of two lines. In a three-quarter or full-length portrait, the face is the center of interest—thus, the face should be positioned to fall on an intersection or on a dividing line.

Usually the head or eyes are placed at the top one-third line of a vertical photograph. Even in a horizontal composition, the eyes or face are usually at the top one-third of the frame—unless the subject is seated or reclining. In that case, they may be at the bottom one-third line.

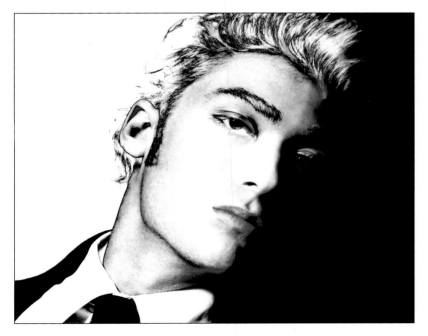

Senior specialist David Humphrey wants his subjects to have a unique look. Notice that the composition is divided in halves by the implied diagonal line running through the line of his nose. The eyes are located near an intersection of thirds. The student wanted an edgy look, which was enhanced in Photoshop with Humphrey's B&W Man Ray action.

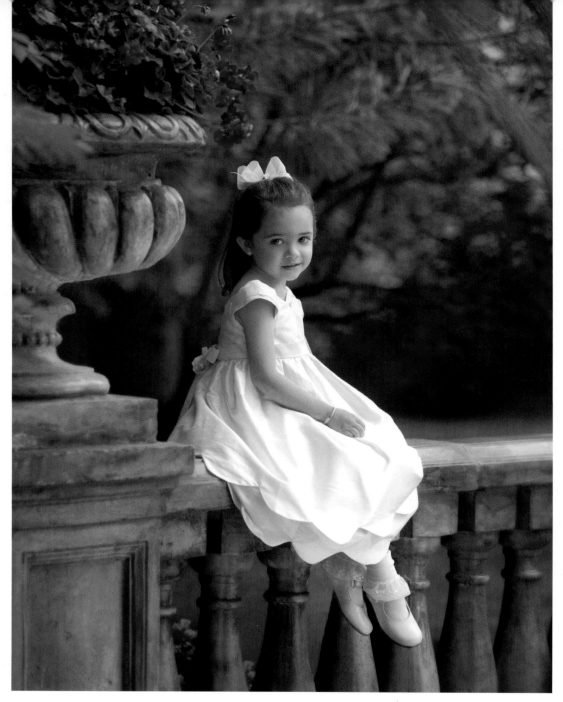

LEFT—This is a very formal children's portrait done by Drake Busath. The child's seated form mimics the classic L-shaped composition, and the line of the portrait, starting with the floral urn in the upper left corner and ending at the lower right corner, is a long, elegant diagonal, with several contrasting diagonal lines visible in the upper right-hand corner of the composition. Note that the posing of the hands is simple, not overdone, and the young girl's expression is subtle, denoting a complexity warranted by such a formal composition.

FACING PAGE—There are two ways to imply movement within the frame. First, you can position the subject past the center line in the image, denoting a sense of leaving a place. Second, you can position the subject in front of the center line in the image, denoting a sense of going to a place. Look at how these two photos by Nichole Van Valkenburgh differ in their sense of motion and direction—simply by changing the position of the subject within the frame.

Some DSLRs feature an in-viewfinder grid of the rule of thirds that can be activated at any time. I own two Nikon DSLRs and keep the grid activated at all times because it helps as a reminder to choose a dynamic subject placement. This keeps your compositions from being center-weighted.

DIRECTION

Regardless of which direction the child is facing in the photograph, there should be slightly more room in front of the child than behind him. For instance, if the child is looking to the right as you look at the scene through the viewfinder, then there should be more space to the right side than to the left of the child in the frame. This gives a visual sense of direction.

Even if the composition is such that you want to position the child very close to the center of the frame, there should still be slightly more space on the side toward which

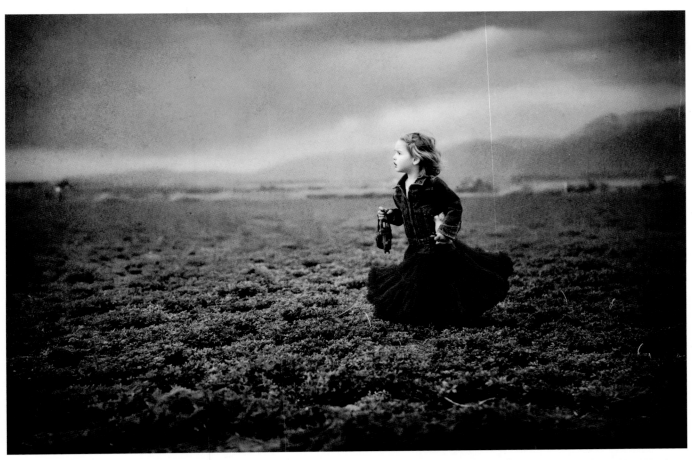

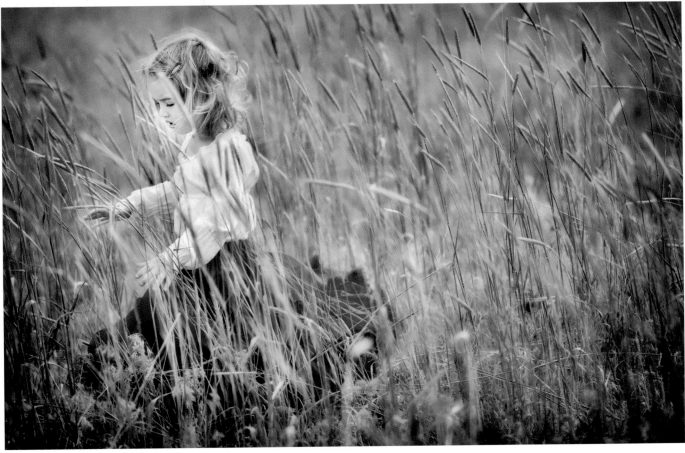

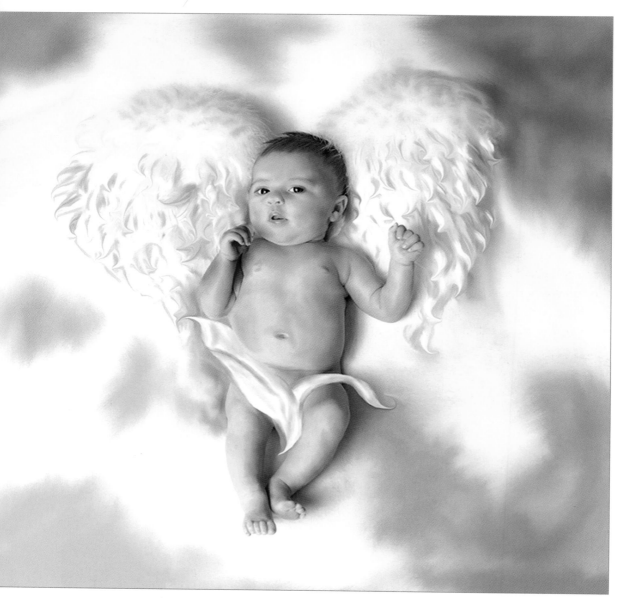

Sometimes, an image can have overpowering symmetry and still create visual tension. In this painterly image by Deborah Lynn Ferro, the winged baby (with wings added by the artist) is centered in the square composition, left to right and top to bottom. Providing the needed visual contrast is the swirling lavender background added by the artist to create a different visual weight in each of the four corners.

he or she is turned. When the subject is looking directly at the camera, he or she should still not be centered in the frame. There should be slightly more room on one side or the other to provide visual direction.

PLEASING COMPOSITIONAL FORMS

Shapes in compositions provide visual motion. The viewer's eyes follows the curves and angles as they travel logically through the shape and, consequently, through the photograph. Subject shapes can be contrasted or modified with additional shapes found either in the background or foreground of the image.

The S-shaped composition is perhaps the most pleasing of all. The center of interest will usually fall on a one-third line, but the remainder of the composition forms a gently sloping S shape that leads the viewer's eye to the area of main interest.

Another pleasing type of compositional form is the L shape or the inverted L shape. This type of composition is ideal for reclining or seated subjects. The C and Z shapes are also seen in all types of portraiture and are both visually pleasing.

The pyramid is one of the most basic shapes in all art and is dynamic because of its use of

diagonals with a strong horizontal base. The straight road receding into the distance is a good example of a found pyramid shape.

LINES

To master the fundamentals of composition, the photographer must be able to recognize real and implied lines within the photograph. A real line is one that is obvious—a horizon, for example. An implied line is one that is not as obvious—the curve of the wrist or the bend of an arm, for instance.

Real lines should not intersect the photograph at the halfway point. This actually splits the composition in two. It is better to locate real lines (either vertical or horizontal) at a point that is one-third into the photograph,

thus providing visual "weight" to the image.

Implied lines should not contradict the direction or emphasis of the composition but should modify it. These lines should feature gentle, not dramatic changes in direction. Again, they should lead to the main point of interest—either the eyes or the face.

Lines, real or implied, that meet the edge of the photograph should lead the viewer's eye into the scene and not out of it. They should also pull the viewer's eyes in toward the center of interest.

TENSION AND BALANCE

Once you have begun to recognize real and implied lines in your scenes and subjects and to incorporate shapes and curves into your

In this Drake Busath portrait, the subject completely dominates the scene because of the white outfit contrasting with the drab, gray wall. The image is in a perfect state of balance; even though there is less white area than gray area, the eye still goes to the little girl. Notice the line of snow atop the wall has been totally subdued so as not to compete with the bright white form of the young girl.

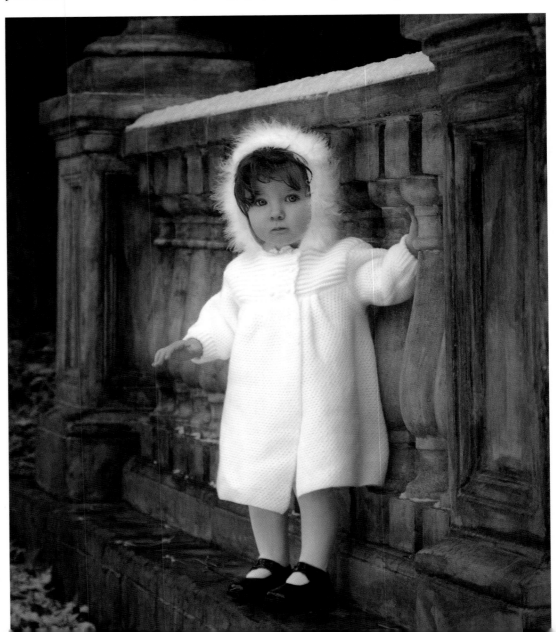

portraits, you can start employing tension and balance. Tension is a state of imbalance in an image—a big sky and a small subject, for example. Tension can be referred to as visual contrast. Balance is where two items, which may be dissimilar in shape, create a harmony in the photograph because they are of more-or-less equal visual strength. Although tension does not have to be "resolved," it works together with the concept of balance so that, in any given image, there are elements that produce visual tension and elements that produce visual balance.

For example, a group of four children on one side of an image and a pony on the other side of the image produce visual tension. They contrast each other because they are different sizes and not at all similar in shape. But the photograph may be in a state of perfect visual balance by virtue of what falls between these two groups or for some other reason. For instance, using the same example, these two different subjects could be resolved visually if the larger group, the children, is wearing bright clothes and the pony is dark colored. The eye then sees the two units as equal—one demanding attention by virtue of size, the other gaining attention by virtue of brightness.

SUBJECT TONE

The eye is always drawn to the lightest part of a photograph. The rule of thumb is that light tones advance visually, while dark tones retreat. Therefore, elements in the picture that are lighter in tone than the subject will be distracting. Bright areas, particularly at the edges of the photograph, should be darkened—in printing, in the computer, or in the camera (by masking or vignetting)—so that the viewer's eye is not distracted from the subject.

FOCUS

Whether an area is in focus or out of focus has a lot to do with the amount of visual emphasis it will receive. A background that is lighter

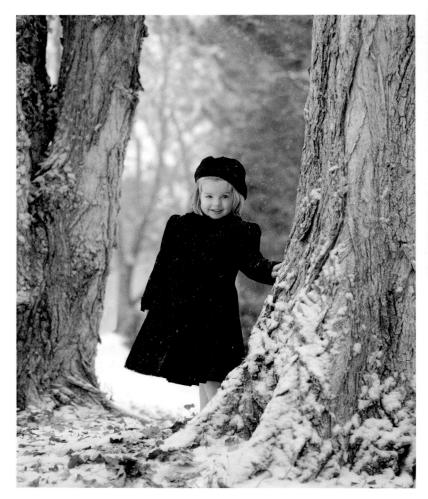

than the subject but distinctly out of focus will not necessarily detract from the main subject. It may, in fact, enhance the image, keeping the viewer's eye centered on the subject.

The same is true of foreground areas. Although it is a good idea to make them darker than your subject, sometimes you can't. If the foreground is out of focus, however, it will detract less from the subject, which, hopefully, is sharp.

A technique that is becoming popular is to diffuse an area of the photograph you want to minimize. This is usually done in Photoshop by creating a feathered selection of the area. Using this technique, the diffusion effect diminishes the closer you get to the edge of the selection.

At least two highly effective techniques are at work in this portrait by Drake Busath. The tone of the portrait is decidedly high-key, but the subject dominates because of the dark tone of her hat and coat. Also, the young girl is positioned between two stately trees, creating visual brackets on either side of her. The effect is to rivet your eyes on the subject.

Clothing is really the best form of "prop" for a child's portrait. Fine clothing, like a christening gown, can define the moment. Other clothes, like jeans and a cowboy shirt, can define personality. A child's best clothes are always handpicked lovingly by Mom—and the children adapt an air of confidence when they are dressed in "Mom's favorite" clothes. There is something beautiful and memorable about a crisply dressed child with his or her hair combed neatly and dressed in their finest clothes. It's special for the parents and the children—and it usually doesn't happen very often. Keep in mind, though, that very little children can sometimes get lost in their clothes. Sometimes it is just as appealing to show a little skin—arms, legs, and most definitely hands.

UPSCALE OR AVERAGE

Portrait photographers Brian and Judith Shindle believe in the upscale prop. Several years ago, Brian purchased a christening gown from Nieman Marcus for $1500. It is the studio's

It is important to know when to highlight clothing and when to subdue it. Here, a very plain dress that blends evenly with the dog's white coat allows the viewer to focus on the girl's face, which is the obvious center of interest in this portrait. A strong color would have created a disharmony within the portrait. Photograph by Prem Mukherjee.

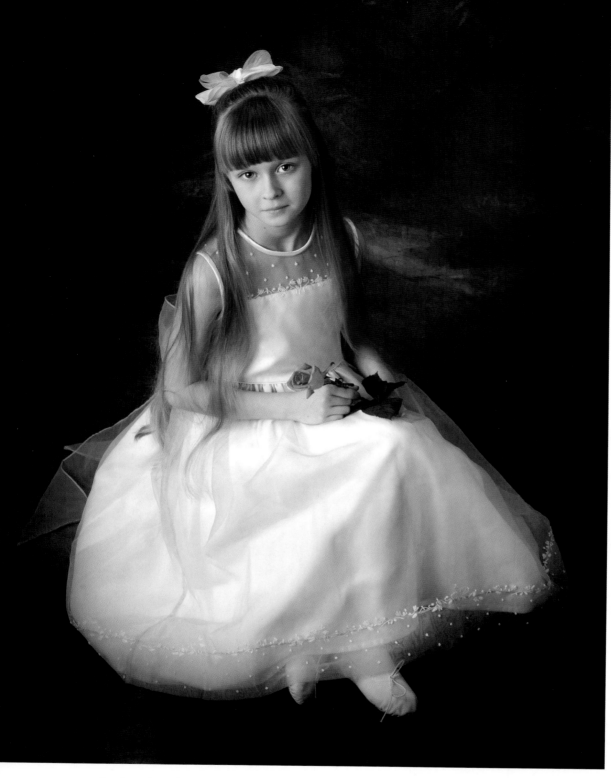

way of enhancing the timeless quality of the child's portrait and can enrich the portrait experience from the client's perspective, making the session more gratifying. However, such elegance is not without risks. Every time Brian takes the gown out of its special bag, he hopes his little client won't throw up all over it.

CONSULTATION MEETING

Clothing should be discussed and coordinated during a pre-session meeting. All of the specific items for the shoot should be coordinated with the clothing, so that props like blankets and stuffed animals have colors that complement one another. When photographing chil-

dren outdoors or on location, it is important to dress them in clothing that is appropriate to the setting. For example, if the photo is going to be made in an elegant wood dining room, don't arrange for the child to wear shorts and sneakers. A child's portrait is meant to be enjoyed for generations to come, so trendy clothing should also be avoided in favor of more classic styles.

Arrange for the parents to bring more than one outfit. At least one outfit should be all solid colors without designs. If more than one child is being photographed—a brother and sister, for instance—clothing should be in complementary or matching colors. Gaudy designs and T-shirts with writing (or worse, cartoon characters) should be avoided. As Suzette Nesire notes to clients, "Keep in mind the final images will be presented on your walls in your home. No stars and stripes and as few logos as possible." Also, new clothes may not be comfortable for the child, so you may want to start the session with the child in casual, familiar clothes, then work up to the dressy outfit.

People don't realize that the wrong selection of clothes can ruin the photograph. That is why it is so important to discuss this prior to the session. Having to re-shoot the portrait is costly and inefficient for both the customer

Let's face it: not all baby outfits are cute. They are gifts from relatives who perhaps haven't had children in many years or who never had children. Many a photo session has been scheduled because of such gifts. A pre-shoot consultation will help the photographer plan for such outfits as the lavender and green one shown here. Photograph by Jeff Hawkins.

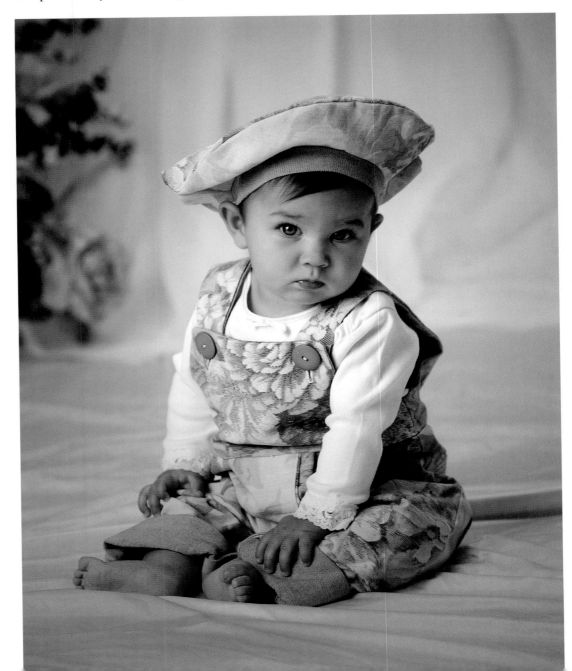

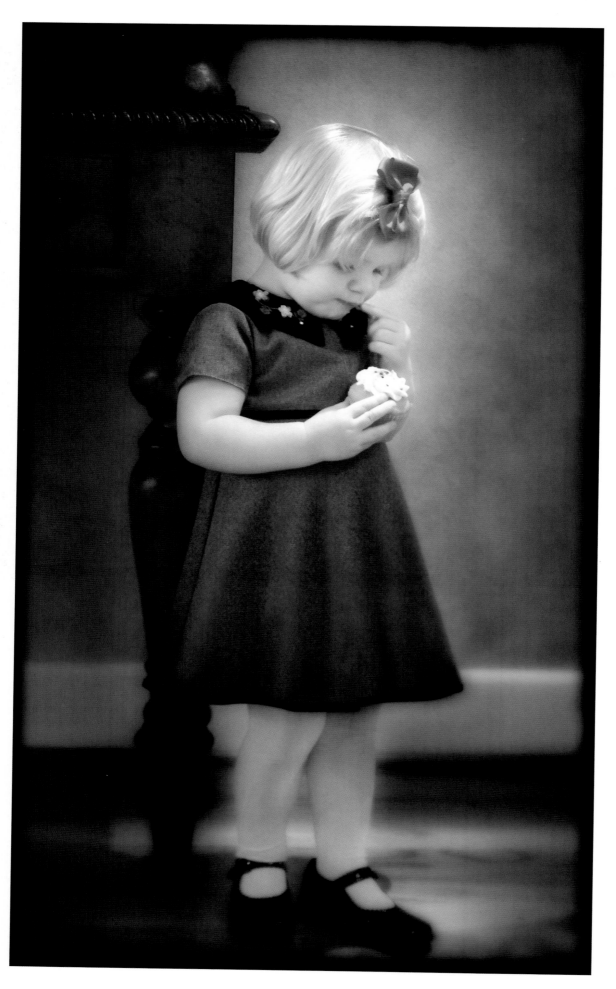

Everything about this photograph by Kersti Malvre, entitled *Cupcake,* is perfectly coordinated. The large dark furniture is barely showing—it's just enough to give the portrait scale—and the little girl's outfit is priceless. Kersti spends a lot of time with her clients, often staying a few days as they get to know each other. As a result, the portraits are filled with detail and always extremely well coordinated.

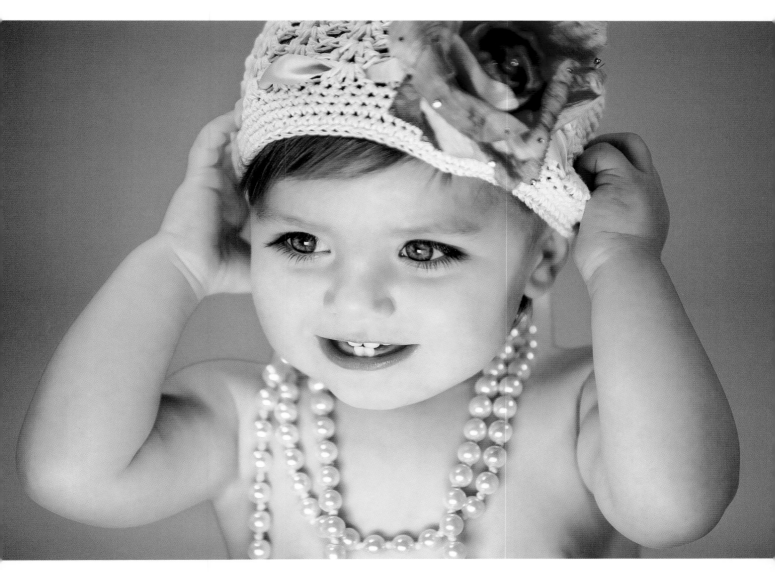

Crazy hats and
pearls—what could
be a more perfect
ensemble for a
toddler? Photograph
by Ruzz.

and the photographer. Below are several topics that should be covered in the consultation.

Dark and Light Colors. Darker clothing helps to blend the bodies with the background, so that the faces are the most important part of the photograph. As a general rule, dark colors slenderize the subject while light colors seem to add weight to the bodies. While this point is usually not a factor with children, with some overweight or skinny children it could be.

The color of the clothing should always be toned down. Bright colors pull attention away from the face. Prints and patterns are a distraction and, in the case of digital portraits, small patterns (even small herringbone or checkered

patterns) can cause unattractive moiré patterns to appear in the fabric.

Glasses. You see more and more children wearing eyeglasses these days. For the child's portrait, glasses may or may not be worn, depending on the parent's or the child's preference. Non-reflective lenses are helpful to the photographer, who will be restricted as to the lighting setup when eyeglasses are a part of the portrait. Sometimes it's possible to obtain a matching set of frames with no lenses. This is particularly helpful if the child's glasses distort the outline of his or her face.

Shoes. Shoes are often a problem on small children. The soles are usually ugly and they can sometimes dominate a portrait. Most fru-

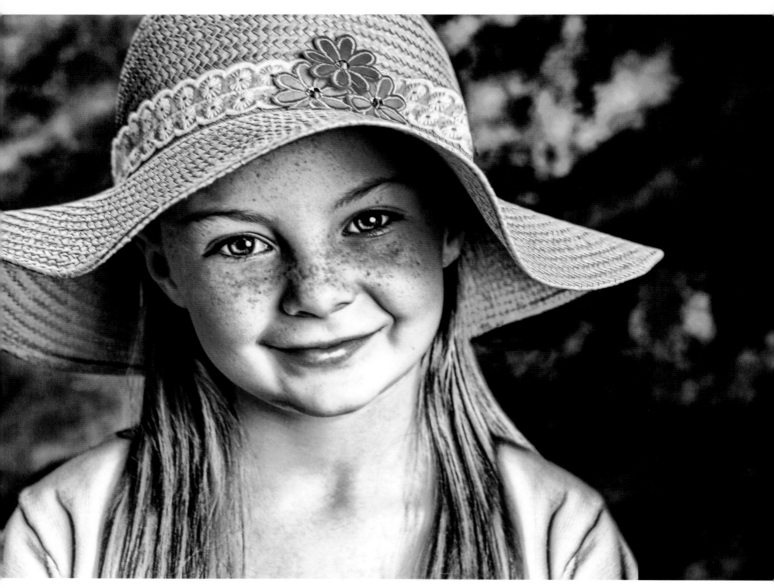

gal parents purchase shoes in the hope that they will "still fit in a month," so they are often a little loose and look large. Some photographers, if the scene and clothing warrant it, will have the child remove his or her shoes—after all, children's feet can be cute.

Hats. A child will often feel right at home in his or her favorite hat or cap. When working outdoors in open shade, hats provide some overhead blocking of the diffused light—like little overhead gobos—and minimize the overhead light on the child's face. In the studio, you must be careful to get light under the brim of the hat to illuminate the subject's eyes.

ABOVE—Hats can make a portrait. This flowery, floppy sun hat seems to suit the personality of this freckle-faced beauty. The image was made using available light, then treated with the LucisArt plug-in in Photoshop by Cherie Frost, the photographer's wife, studio manager, and Photoshop/retouching expert. Photograph by Frank Frost. **FACING PAGE**—The photographer should pay attention to how clothes look on the child. A good second set of eyes like an assistant or parent can help keep an eye on how the clothes are fitting. Here the young boy's jacket and jeans look great—as does he in this action portrait. The clothes and the pose are so refined that this could be a fashion ad. Photograph by Tero Sade.

Exotic hats are always a big hit with kids and range from pointed wizard hats in bright colors to little sailor's hats. Many children's photographers have a collection of ridiculously cute hats. They are silly, colorful, and pretty goofy in general—but kids seem to love wearing hats in their portraits.

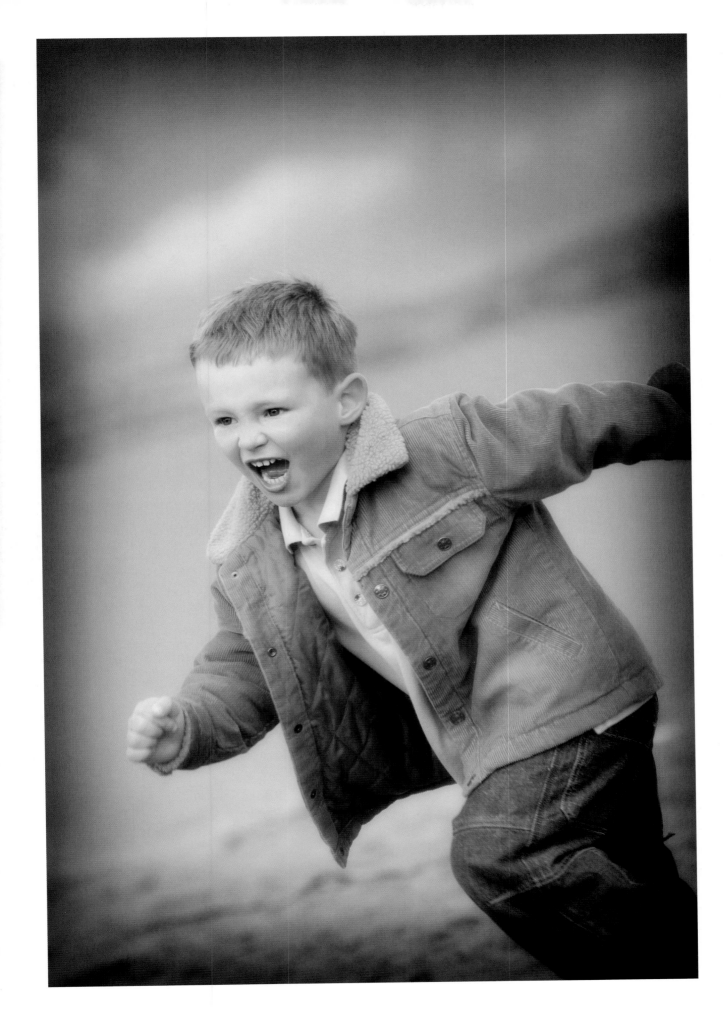

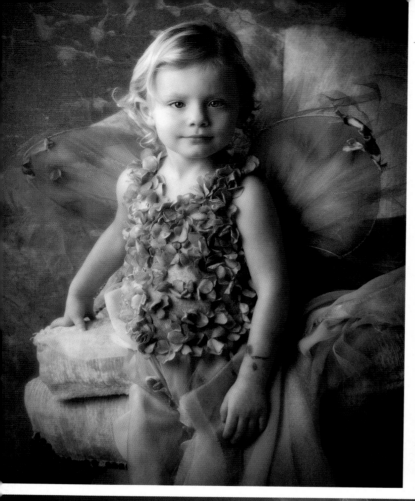
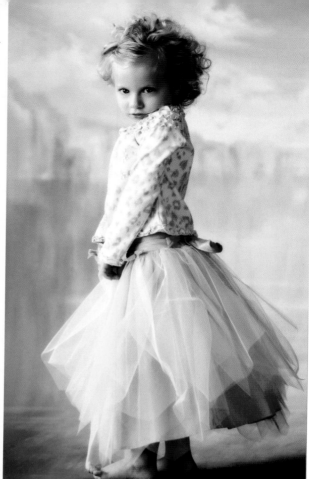
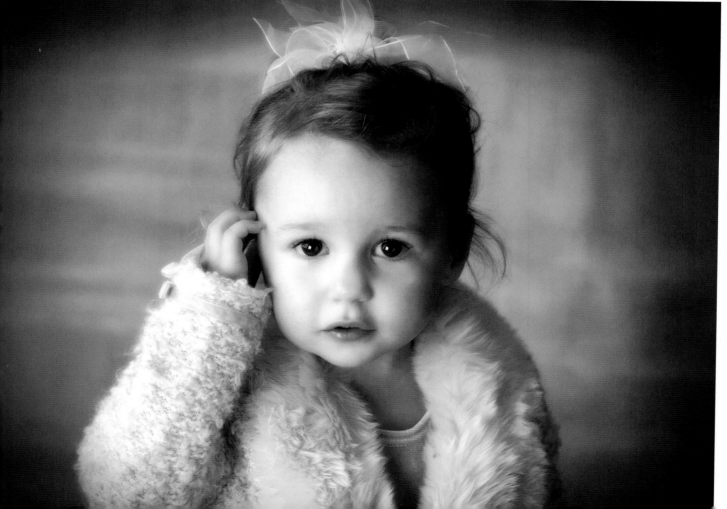

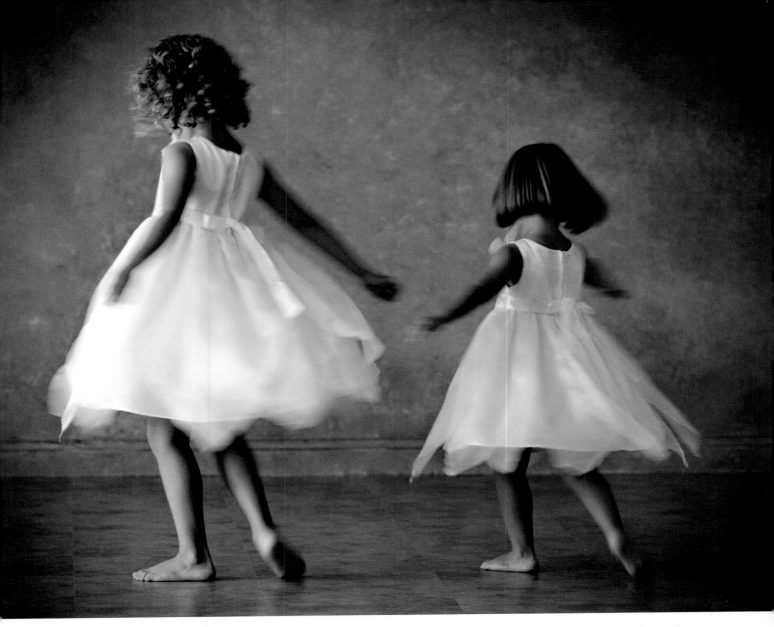

PROPS AND COSTUMES

Fantasy Costumes. Some children's portraits involve dressing the kids up as fairies, mermaids, angels, or other mythical characters. As a result, the "property departments" of many studios are brimming over with costumes, hats, veils, boas, feathers, angel wings, and more. These need to be loose fitting, so that they can be adjusted to fit any child. Fairies are a popular fantasy, so items that can enhance a basic costume are always valuable. Of course, a wide variety of costumes are also available commercially from many sources.

Fabrics. Many children's portrait photography studios maintain an extensive supply of vibrantly colored fabrics—cotton, linen, burlap, mesh, gauze, and just about any kind of exotic cloth you can think of! These fabrics can be draped beneath or around the child to fashion a costume or loosely pinned to form a smock or gown, depending on the material.

Forest Scenes. Props for these portraits might include logs, rocks, or tree stumps (all artificial, lightweight, and commercially available). These are used to build a forest scene or wooded-glen set, for example. To garnish the portrait, artificial leaves, plants, and flowers can be positioned near and around the children. Small props, like woodland animals, frogs, butterflies, birds, and so on are also

used to add to the illusion of the fantasy portrait. Small garlands of artificial flowers are often used as headbands. Garlands are also sometimes loosely arranged within the photograph as color accents.

Antiques. Small antique suitcases are also popular; they are often used to create the illusion that the child is traveling to some exotic location. Some studios also have antique rocking horses, tricycles, and more—stuff the photographers have picked up over time.

BACKGROUNDS

Along with a wide range of props, costumes, and accessories, the photographer offering this style of portrait must also have a wide range of hand-painted canvas backgrounds, which are available through many vendors. These backgrounds are usually done in pastels or neutral tones to complement brighter shades used in the children's costumes, and can be either high-key or low-key in nature. Sometimes, the details in these backgrounds are purposely blurred so they do not attain too much visual attention in the photo.

Some photographers hand-paint their own backgrounds using acrylics and a thin-gauge canvas. Other photographers use soft muslin backdrops that can be hung or draped in the background. There are even "crushable" painted backgrounds that catch highlights and shadows in their folds and wrinkles, producing a dappled look.

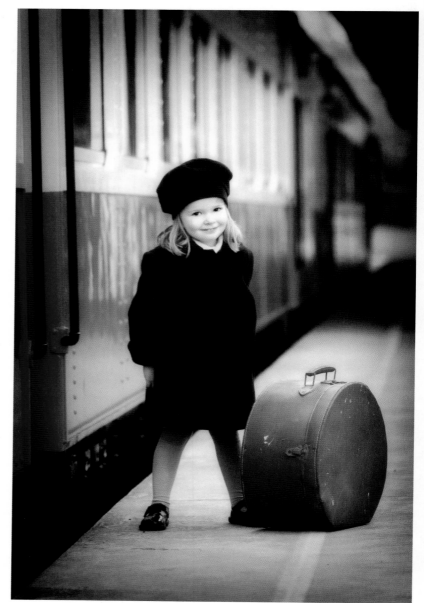

With older children, a location shoot can be fun. This great image by Tero Sade features a traditional children's theme: leaving home for an adventure.

8. OLDER CHILDREN, TEENS, AND SENIORS

Photographing older children requires a different mind-set than working with small children and babies. Adolescents and high-schoolers require patience and respect. They also want to know the details—how long the session will take, what is involved, etc.

CONSULTATION

When you meet with the teen and their parents before the photo session, suggest that they bring along a variety of clothing changes. Include a formal outfit, a casual "kickin' back" outfit (shorts and a T-shirt), an outfit that is cool (one that the senior feels they look really great in), and an outfit that represents their main interest (a sports or cheerleading uniform, etc.). You can also encourage kids to bring in their favorite items—or even a pet. This will help reveal their personalities even more and, like small children, the presence of their favorite things will help them feel relaxed and at home.

NO PARENTS AT THE SESSION

Teens probably will not feel comfortable with a parent around. Instead, ask them to bring along a friend or two and photograph them together. Most parents still think of their teens as little kids, not young adults. As a result they

Simple, elegant, and beautiful. That's what Wisconsin senior photographer Fuzzy Duenkel creates with his senior portraits—all at the kids' homes, too. It's important to Fuzzy that the kids look great, so the girls will undergo a makeup session (usually at the studio) prior to the photo shoot. This portrait harnesses two windows behind the girl, which add subtle edge lighting, and a 22-inch Larson softbox on a light stand with a Canon 580 EX II that provides soft, frontal light.

often make them feel self-conscious and awkward—the last thing you need when you make their portrait. You need to assure the parents that, by excluding them, you have their best interests at heart and that you want to be able to provide them with photographs that will make them happy and proud.

HIGH-END SENIOR STUDIOS

Senior portraits are usually done by the schools on picture day, but that is not the type of senior portraiture referred to here. Many studios have taken to offering high-end, very hip, upscale senior sittings that allow the kids to be photographed with their favorite things in their favorite locations. For instance, a senior's car, usually a treasured possession, is a prime prop included in these sessions.

Often senior sessions will involve the subject's friends and favorite haunts. Or, in the case of senior girls, they will want to be photographed in a fashion/glamour pose, wearing something pretty racy—like what they see on MTV. This is all part of the process of expressing their individuality and becoming an adult. Instead of resisting it, many smart photographers are now catering to it. (*Note:* With these types of sessions, it is important to have a pre-

Photographers specializing in senior portraits have to possess a youthful imagination to keep up with their clientele. This image, called *Closed Angry Minds*, no doubt appeals to Craig Kienast's seniors.

Beth Forester's senior portraits employ an extensive makeup and styling session prior to the shoot and then fashion-type treatment of both the lighting and posing. Her results are upscale and very sophisticated.

my iPod • my music • my life

Ask me how I got my photos on iTunes . . .

beth forester PHOTOGRAPHY

At Beth Forester's studio, seniors who reach a certain level of spending have their images posted to Apple's iTunes store as a podcast. "That's how the viral marketing starts," she says. "Our clients share the podcast with their family and friends by directing them to the iTunes store to download it. By playing their show for hundreds of friends after downloading it to their own video iPod or iPhone, they are showing your product to hundreds of potential clients." To learn more, visit: www.foresterphoto .com/podcast.

shoot meeting with one or both parents to determine what is expected and anticipated.)

POSING

Adolescents and high-school seniors will react poorly to portraits featuring traditional posing, yet some structure is needed to design a successful image. The best way to proceed is to choose a natural pose.

Relaxed and Natural. With boys, find a pose that they feel natural in and work out of that pose. Find a comfortable seat, even if it's on the floor of the studio, and then refine the pose to make it a professional portrait. A good pose for teenage boys is to have them thrust their hands in their pockets with the thumbs out. It is a kind of "cool" pose in which they'll feel relaxed. Be sure to keep space between

LEFT—Fuzzy Duenkel created a rugged pose for this portrait of a baseball player. This image was created in the boy's garage, where a background was positioned in the garage doorway (so the young man stood with his back to the outside). A Fuzzyflector was positioned on the ground in front of the subject to catch the backlight and redirect it as frontal light. Notice the incredible highlight detail and the glistening specular highlights of the sweat on his face.

LEFT—Canadian photographer John Ratchford says that in Canada they don't have what we refer to here as a senior market. John has built his business from scratch in an area that is economically challenged, making the senior market very tough. John often likes to create really dramatic images of his seniors, which is one way he captures attention for his work and his studio. ABOVE—John Ratchford will travel to multiple locations and spend the better part of an entire day shooting a senior. In this image, he chose to create a story—as if the beautiful girl is waiting for someone special. Perhaps she's been waiting so long she doesn't even want the protection of the umbrella. She's soaking wet and completely absorbed in her thoughts. For a senior portrait, this is taking it to the next level.

their arms and body. Another good pose for boys is to have them sit on the floor with one knee up and wrap their hands around the knee, a variation on the "tripod pose" described earlier for children. It is a casual pose from which many variations can be achieved.

Girls want to be photographed at their best—looking slim and beautiful. Therefore, it is imperative to use poses that flatter their figures and make them look attractive.

Active. Seniors and teens like activity and bright colors in their portraits. They also like their music playing in the background as they pose, so ask them to bring along a few CDs when they come to have their portrait made. Work quickly to keep the energy level high.

Try to photograph several different settings with at least one outfit change. Show them the backgrounds and props that you have available and ask them to choose from among them. You should have a wide variety of backgrounds and props to choose from. You will be surprised at what they select.

PSYCHOLOGY

Part of your job is to make your subjects feel good about themselves. This can take the form of reassurance or flattery, both of which should be doled out in a realistic, believable way. Like all kids, teens will react positively to your enthusiasm and positive energy as long as they feel it's genuine.

It is often said that one of the qualities of a great portrait photographer is an ability to relate to other people. With teens, a genuine interest in them as people can go a long way. Ask them about their lives, their hobbies, their likes and dislikes, and try to get them to open up to you. Of course, this is not always easy. Some teens are introspective and moody and

Diamonds are a girl's best friend

David Humphrey is a senior specialist who loves working with teens and gives them what they want to see in their images. Here, he created a high-dynamic range (HDR) version of a portrait for this softball catcher. He often uses graphics and type in his images.

Over the years, Larry Peters has developed many styles to offer his student clients. This style is pure elegance, taking advantage of the rich setting of the home and the photographer's refined sense of color coordination and art direction.

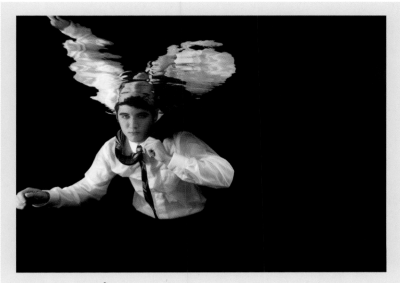

Keep Evolving

Larry Peters has been photographing seniors for a long time and he loves it. His latest creations are underwater fantasy images that capture the weightless ballet of simple movements underwater. He captures his young underwater adventurers with his Canon 5D in an Ikelite waterproof housing with a 17–35mm lens. He creates the effect of a bottomless depth by using a submersible black backdrop behind the senior. Larry basically puts the shallow end of the studio pool into a giant softbox by erecting a white popup tent over their heads. You might think these photographs were taken in deep water; actually if the senior just stands up straight, their feet will touch the bottom of the shallow pool and their heads will come out of the water. This makes the subjects feel calm, in control and safe in the unusual setting. Why shoot senior portraits underwater? Larry's answer lies in the necessity of developing new products. This has become more important as amateur point-and-shoot cameras have improved. "As professionals, we have to offer products to wow the client—things that Uncle Bob cannot achieve with his new digital camera. Only images with the 'wow' factor will motivate tomorrow's client to invest in professional photography."

it will take all of your social skills to bring them out of their shells.

Part of being a good psychologist is watching the subject's mannerisms and expressions. You will get a chance to do that if you have a pre-session meeting, which is advisable. Take notes as to poses that the client may fall into naturally—both seated and standing. Get a feeling for how they carry themselves and their posture. You can then use this information in the photo session. Such insight makes them feel that you are paying attention to them as individuals.

This is important, as one of the differences between big kids and little kids is that the older ones think of themselves as individuals. They will often have unique clothes, hair, tattoos, or piercings that set them apart. Instead of reacting negatively to their uniqueness, show your appreciation. Also, keep in mind that seniors are at a transitional age. These clients often have boyfriends or girlfriends and are thinking about college and about leaving home—all of which can make life confusing. A portrait made at this stage of their lives is a valuable heirloom, because they will never look or act quite like this again.

You may also have to exercise a little less control over a senior setting. Teens want to feel that they have control, particularly over their own image. You should suggest possibilities and, above all, provide reassurance and reinforcement that they look great. Often, the best way to proceed is to tell your subject that you will be making a series of images just for Mom and Dad, but you'll also make some images just for them.

THE MANY FACES OF . . .

As with any good portrait sitting, the aim is to show the different sides of the subject's personality. Adults have all sorts of armor and subterfuge that prevent people from seeing their true natures. Teenagers aren't nearly that sophisticated—but, like adults, they are multifaceted. Try to show their fun side as well as their serious side. If they are active or athletic, arrange to photograph them in the clothes worn for their particular sport or activity. Clothing changes help trigger the different facets of personality, as do changes in location.

9. STORYTELLING BOOKS

A recent development in children's portraiture is the creation of the storytelling album, which is very similar to a bound wedding album. These albums contain a variety of images that may capture a special event in a child's life or, more broadly, a whole year of their life—with all their accomplishments and personality traits. Parents cherish these albums as reminders of a childhood that passes all too quickly.

PATTI ANDRE'S SIGNATURE STORYBOOKS

Patti Andre, owner of As Eye See It Photography in Rancho Santa Fe, CA, calls her beautiful children's albums "Signature Storybooks." Clients commission her books not only because they want to commemorate important events, but also because her books are works of art.

Patti and her husband, Tom, did months of research on potential album designs, trying different bindery shops and album companies, until they came up with the perfect treatment. Patti says. "Our books are very labor-intensive because we do absolutely everything—from the design and layout to printing the pages on our Epson 7600 inkjet printer." Then, they outsource the final gluing, binding, and specialized covers.

To start each project, Patti makes 2x3-inch proofs of just her favorite images for layout purposes and to begin a story line. Clients then receive a full working proof book of 2x3 prints. According to Patti, "Every page is built from scratch and customized, depending on the progression of the story. Having a close working relationship with clients allows me to find out what they like."

Patti shoots in RAW format because it is like a negative. She can go back to the unaltered original anytime, which is not the case when shooting JPEGs. "Dodging and burning in the darkroom," she says, "did not affect the original negative. RAW works the same way." Adds Patti's husband Tom, "The only downside of shooting RAW is the huge files."

NEXT FIVE PAGES—Capri's mom found out she was pregnant when she was about to undergo breast augmentation surgery. The surgeon came in and said, "We can't operate on you—you're pregnant." And so begins the story. "I worked with Patti Andre on a storybook for my daughter Capri Michael Nova," says Capri's mom. "We decided that we would focus on Capri's first year of life—from conception through pregnancy and labor, and ending with her first birthday. Patti exceeded my every expectation with her beautiful creation. I almost cried the first time she presented me the book. Her mixture of text, images, and color could not have more perfectly embodied all of the feelings that my daughter and I shared for her first twelve months. I received a big book and a mini-book (which I carry in my purse everywhere). I have decided to work with Patti every year on a book for Capri so that when she is eighteen, I can present her with the whole series, walking her through all of the special moments she gave me and our family. For me, this is more than a storybook. It's a legacy that I can pass down."

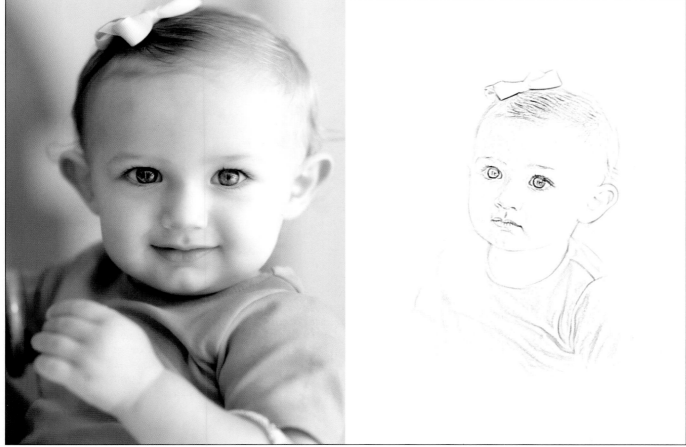

11/23 – 11/26 (November 21st, 2003 – conception date) Mozzi/Capri was conceived one early morning (6am-ish) downstairs in the kitchen over a faucet which subsequently became broken.

WHAT IS A NOVA?

A NOVA IS A STRONG, RAPID INCREASE IN THE
BRIGHTNESS OF A STAR. THE WORD COMES
FROM LATIN FOR "NEW STAR," BECAUSE
OFTEN A STAR PREVIOUSLY TOO DIM TO BE
SEEN WITH THE NAKED EYE CAN BECOME
THE BRIGHTEST OBJECT IN THE SKY
WHEN IT BECOMES A NOVA.

WHAT IS A SUPERNOVA?

CAPRI MICHAEL NOVA

MASS: 7 LBS 2 OUNCES
DIAMETER: 23 INCHES
ORIGINATION: 8.27.04
CONSTELLATION: VIRGO
FAMILY ORBITALS: MICHAEL, KRISTIE AND EVAN

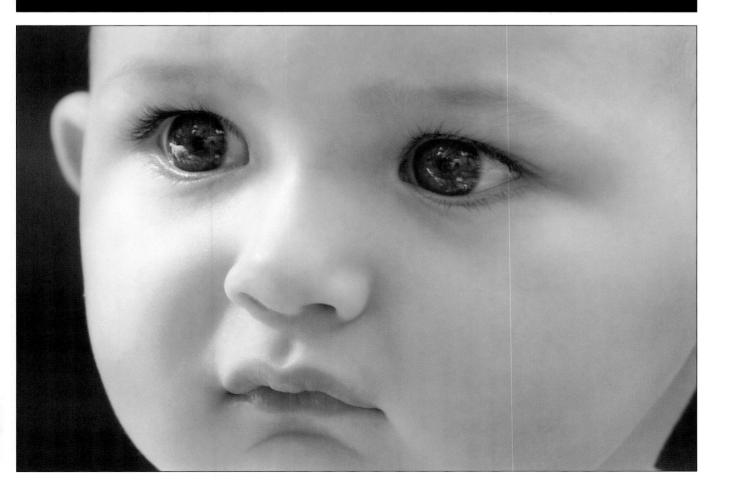

me & mommie...

pink is our thing!!!

ps... mommie finally got her new num nums!!!

My mommie always likes me to wear BIG bows.

the end.

800.862.0723
© 2005 As Eye See It.
www.aseyeseeit.com

Patti loves kids and childhood. As she says on her web site, "We experience it every day, this thing called life. Intertwined with life is this thing called time, and somehow there is never enough of it. No matter how much more we need, it just keeps flying by. We love our children—the sweet smell of their bodies, the silky softness of their skin, and the innocence of their hearts. They are babies one day, and suddenly we turn around and they are five. We watch them play, read their favorite story a thousand times, fix their toys, kiss their cheeks, hold their hands, dry their tears, and give countless snuggles. Each of those minutes is precious. The day comes too soon when they say, 'I can put myself to bed, Mom.'"

Patti says of her albums, "Our books not only tell a story of a moment in time, they are unique and customized in every way. Each book is personalized with notes or letters, artwork or bits and pieces of written words—inspirational words, memories, and maybe some old photographs from Mom and Dad. Each storybook is well thought out and storyboarded. It is a very personal reflection, with countless hours tirelessly spent enhancing images and placing them just so." The blending of Patti's photography with Tom's expertise in the entertainment printing industry has enhanced their storybooks, so the control over the entire process stays with them.

PAGE DESIGN AND LAYOUT

While design is a critical component of any well-composed photograph, good design is even more essential when laying out a book that features a combination of photos, text, and other visual elements.

Left- and Right-hand Pages. Look at any well-designed book or magazine and study the differences between the images on left- and right-hand pages. They have one thing in

Each of Patti Andre's covers for her story-book albums is unique and reflects the inner story in the album. Countless hours are spent on each album, which is a one-of-a-kind treatment.

common: they lead the eye in to the center of the book, referred to as the "gutter."

These photos use the same design elements photographers use in creating effective images: lead-in lines, curves, shapes, and patterns. If a line or pattern forms a C shape, it is an ideal left-hand page, since it will draw the eye into the gutter and across to the right-hand page. If an image is a backward C shape, it is an ideal right-hand page, leading the eye back toward the gutter and the left-hand page.

Often, familiar shapes like hooks or loops, triangles, and circles are also used in the same manner, guiding the eye into the center of the two-page spread and across to the right-hand page.

There is infinite variety when it comes to laying out images, text, and graphic elements to create this left and right orientation. For example, an image (or even a series of photographs) can produce a strong diagonal line that leads from the lower left-hand corner of the left page to the gutter. That pattern can be duplicated on the right-hand page, or it can be contrasted for variety. The effect is visual motion.

Even greater visual interest can be attained when a line or shape that started on the left-hand page continues through the gutter, into the right-hand page, and back again to the left-hand page. This is the height of visual movement in page design.

Suzette Nesire produces beautiful children's albums. One frequently used technique is to reduce the opacity of a major image to diminish its importance on a page. That way, the small photos, here with a dash of orange, balance with the large image. Notice the movement from left to right.

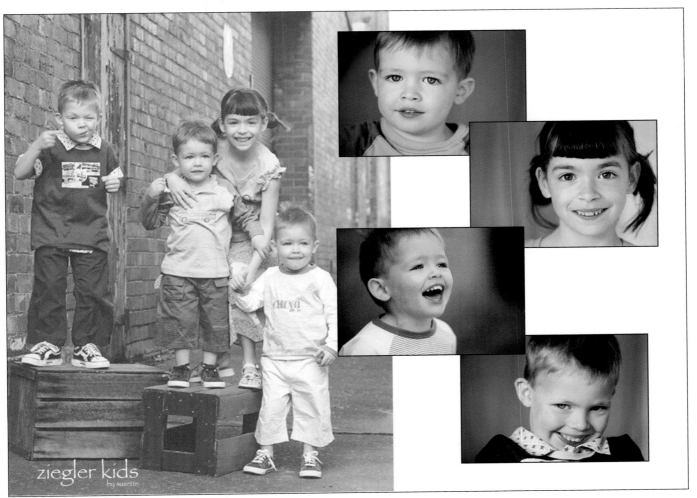

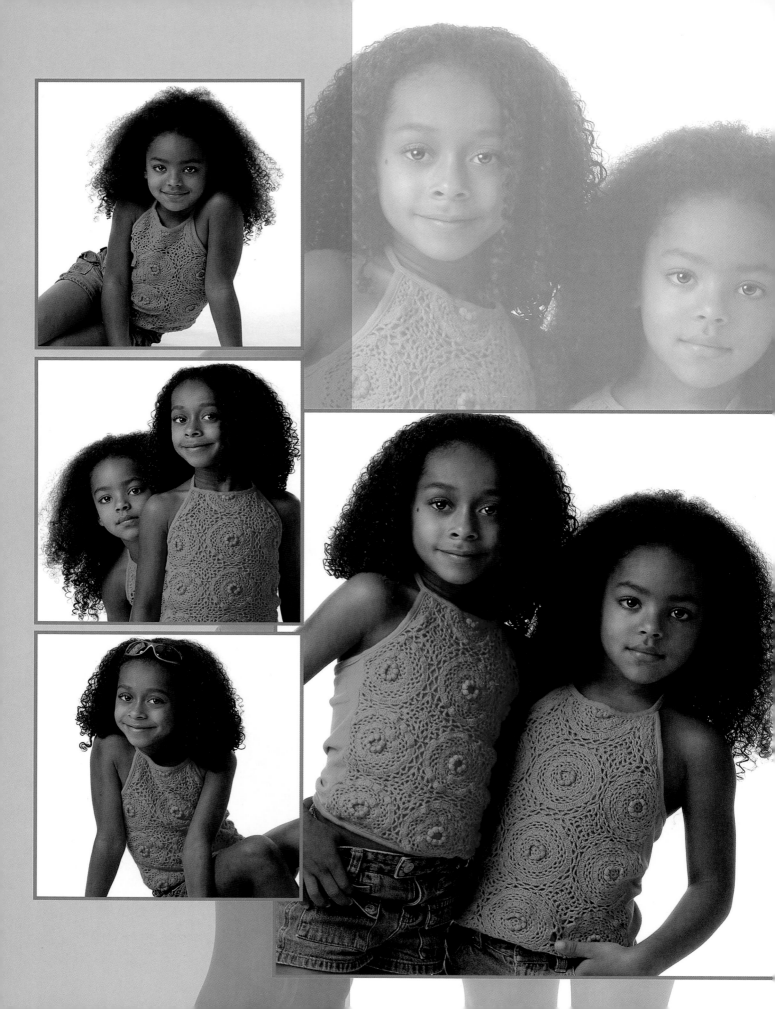

Variety. When you lay out your book images, think in terms of variety of size. Some photographs should be small, some big. Some should extend across the spread. No matter how good the individual photographs are, the effect of a book in which all the images are the same size is static.

Variety can also be introduced by combining black & white and color—even on the same pages. Try combining detail shots and wide-angle panoramas. How about a series of close-up portraits of the child on the left-hand

FACING PAGE—Collage pages work very well for children's albums. This page would be a good left-hand page. Images and page design by Deborah Lynn Ferro.

BELOW—Suzette Nesire often puts together pinwheel pages together that reveal four sides of a child's personality, or four unique moments in a child's day. The result is a stellar album page.

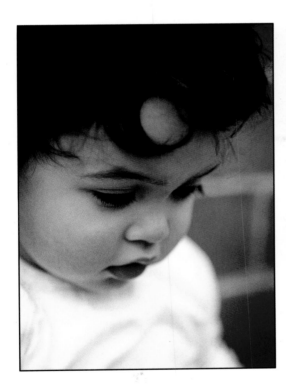

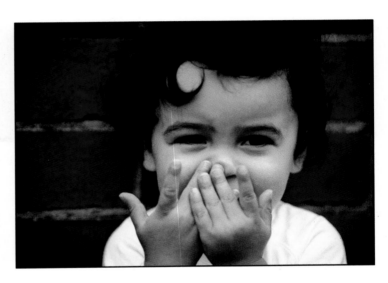

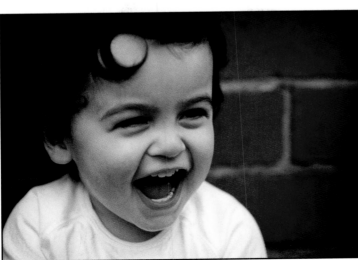

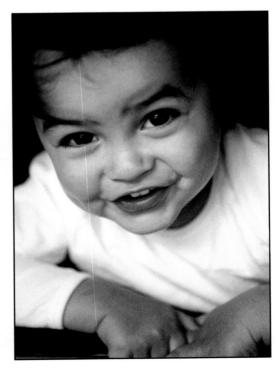

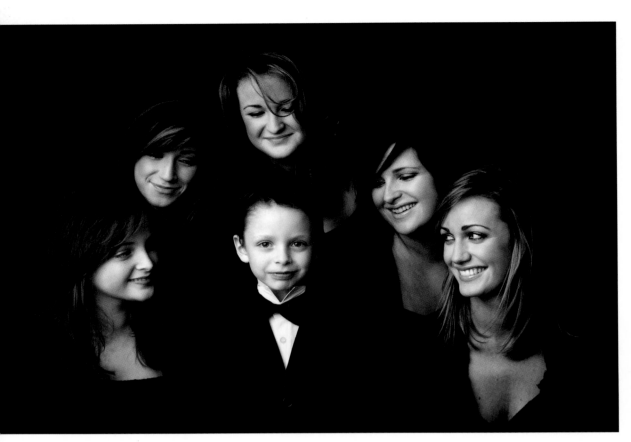

Sometimes a strong image with a symmetrical composition, such as this pyramidal shape, is ideal for the final or first page of an album. Photograph by Mark Nixon.

page contrasted with a wide-angle shot of the child's favorite pet, toy, or even his bedroom? Do not settle for the one-picture-per-page theory. It's static and boring.

Left to Right. Remember a simple concept: in Western civilization we read from left to right. We start on the left page and finish on the right. Good page design leads the eye from left to right and it does so differently on every page.

SEQUENCES

If story albums are similar to a novel, then a sequence is more like a short story. Sequences are appropriate when a single photograph just doesn't convey the many wonderful things that happened in a photo session, or when you want to portray the different sides of an event or special day, such as a first birthday party.

Often, sequences are shot rapid-fire to document some action. They can also be a series of varied expressions taken from the same angle, depicting the many sides and moods of the child. These images are often displayed on mount boards or in folders and should follow the principles of good page design and layout; you should be able to trace line, form, direction, movement, tension, and balance within the assembled images.

As this second edition is being concluded, we are starting to come out of the worst recession in a very long time. Many photographers who were making big money shooting weddings have seen wedding budgets slashed to a fraction of what they were. Survivors have had to modify and adapt their businesses to the changing times and one of these modifications is to revive their client lists of former wedding customers. After all, young couples just starting families may scrimp and save and get by for themselves, but they will spend heartily on their children.

As a result, many of the ultra-successful (and even average) photographers who, one year ago, specialized in wedding photography are now children's portraiture experts, as well. It's a natural connection for the photographer

Photography by Ruzz is a high-end 2000 square-foot studio in Los Angeles. Ruzz, the proprietor, is a fifth generation photographer—and while she has only been in business for a few years on her own, she is commanding top dollar for her weddings and children's packages. She is a good example of the new breed of professional coming onto the scene and her work, as you can see here, is quite special.

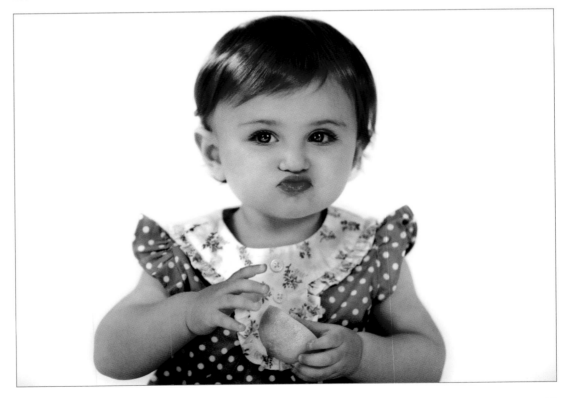

to make, since many of the new parents are past wedding clients.

In reviewing some recent print competitions at WPPI and elsewhere, I have noticed that some of the more stylized techniques of the wedding photographers are finding their way into children's portraiture. It's a good thing to witness; these photographers are breathing new life into this genre of professional photography.

The idea of children's albums, fostered by the same group of photographers who for years have been producing top notch, expensive wedding albums, has become widely accepted and a means of expanding sales in the children's portrait market. "Day in the life" albums, birthday party albums, Bar and Bat Mitzvah albums, first communion and confirmation albums are all becoming quite well accepted among society and are helping the photographer bridge the economic gap between the past and present.

An aspect of photography that is different now from when this book first appeared in print is that there are a greater number of photographers who now call themselves professionals. I hear many complaints from the pros that the cameras are so easy to use and produce such great results that amateurs are "stealing" business from them.

Having been through several such cycles in which the technology has brought more and more people into photography—especially on the professional level—I would say that what separates the professional from the talented amateur is effort and customer service. As Larry Peters points out in chapter 9, he has had to come up with innovative new products that will attract a fickle senior audience, and he's been extremely successful at it over the years. The amateur, who probably has another job and is good at something other than photography, does not realize that the true professionals live and breathe photography all day, every day. Competition never hurt anyone, and those willing to perfect their craft and spend a great deal of time streamlining their business will be successful now as in any other time.

THE PHOTOGRAPHERS

Nick Adams. Nick is a Utah-based photographer who works with his wife, stylist Signe Adams. Nick was a musician before he earned a degree in anthropology from the University of California, Berkeley. From there he became a photojournalist at a Utah newspaper. Signe worked as a costume designer in southern California and has a keen interest in fashion. In 2004 Nick and Signe combined their talents, opening a wedding and portrait studio in St. George, UT.

Alycia Alvarez. Alycia Alvarez has always had a passion for photography. After becoming a mother, she realized how quickly her own children were changing right before her eyes. She began to document their lives, capturing true and genuine personalities. Alycia is an award winner at WPPI and her work is achieving national recognition. Her studio is in Riverview, FL. Her web site is www.alyciaalvarezphotography.com.

Patti Andre. Patti holds a BFA from Art Center College of Design in Pasadena. Her work has appeared in many magazines and her clients include Scripps Hospital, Ketchum Advertising, Saint John's Hospital, Amgen, United Way, USC, and many others. Patti has received numerous awards from WPPI. In 2006, she achieved a first place with one of her albums in WPPI's Awards of Excellence Album Competition. The name of Patti's business is As Eye See It.

Janet Baker Richardson. From a successful career as a producer of television commercials, Janet has subsequently created a meaningful niche in the world of children's portraiture. Janet lives with her family in Los Angeles where she runs a home-based business.

Marcus Bell. Marcus Bell's creative vision, fluid natural style and sensitivity have made him one of Australia's most revered photographers. It's this talent combined with his natural ability to make people feel at ease in front of the lens that attracts so many of his clients. Marcus' work has been published in numerous magazines in Australia and overseas including *Black White, Capture, Portfolio Bride,* and countless other bridal magazines.

Drake Busath *(Master Photographer, Craftsman).* Drake Busath is a second-generation professional photographer who has spoken all over the world and has been featured in a wide variety of professional magazines. Drake also runs a popular photography workshop series in northern Italy.

Anthony Cava *(BA, MPA, APPO).* Anthony owns and operates Photolux Studio with his brother, Frank. At thirty years old, he became the youngest Master of Photographic Arts in Canada. Anthony also won WPPI's Grand Award with the first print he ever entered in competition.

Michele Celentano. Michele Celentano graduated the Germain School of Photography in 1991, then spent the next four years assisting and photographing weddings for other studios. In 1995 she started her own business photography, and in 1997 she received her certification from the PPA. She has since become a nationally recognized speaker on the art of wedding photography and has recently relocated her business from New York to Arizona.

Bruce Dorn and Maura Dutra. These award-winning digital imagemakers learned their craft in Hollywood, New York, and Paris. Maura has twenty years' experience as an art director and visual effects producer, and Bruce capped a youthful career in fashion and advertising photography with a twenty-year tenure in the very exclusive Director's Guild of America. They have earned a plethora of industry awards for excellence in image-making, and now teach worldwide.

Fuzzy and Shirley Duenkel. Fuzzy has been honored with numerous awards, including four Fuji Masterpiece Awards. In 1996 and 1997, he was named Photographer of the Year for the Southeastern Wisconsin PPA. Fuzzy has had fifteen prints selected for National Traveling Loan Collection, two for Disney's Epcot Center, one for Photokina in Germany, and one for the International Hall of Fame and Museum in Oklahoma.

Deborah Lynn Ferro. A professional photographer since 1996, Deborah calls upon her background as a watercolor artist. She is a popular instructor and the author of *Artistic Techniques with Adobe Photoshop and Corel Painter,* from Amherst Media.

Beth Forester. Beth Forester is owner and operator of Forester Photography in Madison, WV. She is a board member for the Professional Photographers of West Virginia and was named Mid-East States Photographer of the Year in 2006 and in 2007. Beth has also earned numerous Kodak Gallery and Fuji Masterpiece Awards.

Frank A. Frost, Jr. *(PPA Certified, M.Photog.,Cr., APM, AOPA, AEPA, AHPA).* Frank Frost has been creating his classic portraiture in Albuquerque, NM, for almost twenty years. Along the way, he has earned numerous awards from WPPI and PPA. His photographic ability stems from an instinctive flair for posing, composition, and lighting.

Jim and Katarina Garner. Jim and Katarina Garner started photographing weddings in 1999. By fusing editorial fashion photography with a more relaxed, candid approach, Jim and Katarina provide each couple with an amazing collection of images, all while allowing the bride and groom to truly enjoy their wedding celebration.

Jo Gram and Johannes Van Kan. Johannes and Jo are the principals at New Zealand's Flax Studios, which caters to high-end wedding clients. Johannes has a background in newspaper photography; Jo learned her skills assisting top wedding photographers. In 2005, they teamed up—and they have been winning major awards in both Australia and New Zealand ever since.

Jeff and Kathleen Hawkins. Jeff and Kathleen operate a high-end wedding and portrait photography studio in Orlando, FL, and are the authors of *Professional Marketing & Selling Techniques for Wedding Photographers* (Amherst Media). Jeff has been a professional photographer for over twenty years. Kathleen holds an MBA and is a past president of the Wedding Professionals of Central Florida (WPCF). They can be reached at www.jeffhawkins.com.

Amber and Nathan Holritz. In 2001, Amber and Nathan started their photography business in Chattanooga, TN, and quickly established themselves as high-end wedding photographers. Amber also shoots about three lifestyle baby sessions a week, in addition to traveling and speaking on the topic, and has produced a number of photographer profiles for *Rangefinder* magazine.

Elizabeth Homan. Elizabeth Homan owns and operates Artistic Images, where she is assisted by her husband, Trey, and her parents, Penny and Sterling. Elizabeth holds a BA from Texas Christian University and was the decorated as the youngest Master Photographer in Texas in 1998. She holds many awards, including ten Fujifilm Masterpiece Awards, Best Wedding Album in the Southwest Region (six years), and two perfect scores of 100 in print competition.

David Humphrey. David Humphrey of Flint, MI, is a senior specialist who has fashioned his business after images that seniors see on MTV. Both his business techniques and shooting techniques are unique and he is very popular among his high-school age clients.

Kevin Jairaj. Kevin is a fashion photographer turned wedding and portrait photographer whose creative eye has earned him a stellar reputation in the Dallas/Fort Worth, TX, area. His web site is www.kjimages.com.

Tim Kelly *(M.Photog.).* Tim Kelly is an award-winning photographer and the owner of a studio in Lake Mary, FL. Since 1988, he has developed educational programs and delivered them to professional portrait photographers worldwide. Tim was named Florida's Portrait Photographer of the Year in 2001 and has earned numerous Kodak Awards of Excellence and Gallery Awards.

Craig Kienast. Working in the small-market town of Clear Lake, IA, Kienast ordinarily gets

more than double the fees of his nearest competitor (about $1200 for most of his high-school senior orders). Samples of Craig's work and teaching materials can be seen at www.photock.com.

Frances Litman. Frances is an award-winning photographer from Victoria, BC, who has been featured in publications by Kodak Canada and in FujiFilm advertising campaigns. She has also been honored with the prestigious Kodak Gallery Award.

Kersti Malvre. Kersti is well known for her unique style of portraiture that merges black & white with oil painting. She holds the PPA Photographic Craftsman's degree for outstanding contributions to the portrait profession.

Prem and Cheridy Mukherjee. Soon after they were married in 2001, Cheridy encouraged Prem to continue to pursue photography. Starting out as a landscape and nature photographer, Prem soon grew to enjoy photographing people. He taught Cheridy how to use a camera and they have been photographing weddings and children ever since. In October 2007 they won the award for Metro Detroit's Best Wedding Photographer. They have since won WPPI awards and continue to excel.

Suzette Nesire. Suzette Nesire is a highly regarded children's portrait photographer from Melbourne, Australia. Her portraits provide an intimate look into a child's world and are proving to be a huge success with all her clients. Her website offers some excellent information about children and photographing them. Visit www.suzette.com.au.

Mark Nixon. Mark, who runs The Portrait Studio in Clontarf, Ireland, recently won Ireland's most prestigious photographic award with a panel of four wedding images. He is currently expanding his business to be international in nature and he is on the worldwide lecture circuit.

Larry Peters. Larry is one of the most successful and award-winning senior-portrait photographers in the nation. His popular web site is loaded with good information about photographing seniors: www.petersphotography.com

John Ratchford. John is from eastern Canada and has introduced the senior-portrait market to Canada. His images have captured many national and international awards. John has a thriving wedding business and is the author of the upcoming book *Essence of Life*, featuring a collection of prenatal and newborn images.

Ruzz. Ruzz is a fifth-generation photographer who specializes in high-end weddings and children's portraiture. She has two web sites: www.ruzzphotography, which features her wedding photography, and www.ruzzpeanutgallery.com, which features her children's portraiture. She owns a 2000-square-foot studio in Los Angeles and works with her son, who she says is also an amazing photographer. Ruzz has been a member of WPPI since 2005 and has received sixteen Accolades of Excellence Awards.

Tero Sade. Tero Sade is one of Australia's leading portrait photographers. In 2003, Tero sold his successful Brisbane business to return to Tasmania, where he donates every sitting fee to Make a Wish foundation. To see more of Tero's work, visit www.tero.com.au.

Tim Schooler. Tim is an award-winning photographer specializing in high-school senior portraits with a cutting edge. Tim's work has been published internationally in magazines and books. His studio is located in Lafayette, LA. Visit his website at www.timschooler.com.

Brian and Judith Shindle. Brian and Judith Shindle own and operate Creative Moments in Westerville, OH. This studio is home to three enterprises under one umbrella: a working photography studio, an art gallery, and a full-blown event-planning business. Brian's work has received numerous awards from WPPI in international competition.

Vicki and Jed Taufer. Vicki and Jed are the owners of V Gallery, a prestigious portrait studio in Morton, IL. Vicki has received national recognition for her portraits, and is an award winner in WPPI print competitions. Jed is the head of the imaging department at V Gallery.

Nichole Van Valkenburgh. Nichole Van Valkenburgh, of Nichole V Photography, LLC in Utah, has won numerous accolades and awards for her unique portrait photography, including International 8x10 Portrait of the Year from WPPI for 2007. A former university professor, Van Valkenburgh merges her love of photography with her teaching experience, presenting photography workshops around the world.

GLOSSARY

Balance. A state of visual symmetry among elements in a photograph.

Barebulb flash. A portable flash unit with a vertical flash tube that fires the flash illumination 360 degrees.

Barn doors. Black, metal folding doors that attach to a light's reflector; used to control the width of the beam.

Bounce flash. Bouncing the light of a studio or portable flash off a surface such as a ceiling or wall to produce indirect, shadowless lighting.

Broad lighting. One of two basic types of portrait lighting in which the main light illuminates the side of the subject's face turned toward the camera.

Burst rate. The number of frames per second (fps) a digital camera can record images and the number of frames per exposure sequence a camera can record. Typical burst rates range from 2.5fps up to six shots, all the way up to 8fps up to forty shots.

Catchlights. The specular highlights that appear in the iris or pupil of the subject's eyes reflected from the portrait lights.

Color temperature. The degrees Kelvin of a light source. Also refers to a film's sensitivity. Color films are balanced for 5500°K (daylight), or 3200°K (tungsten), or 3400°K (photoflood).

Cross-lighting. Lighting from the side of the subject that skims facial surfaces to maximize texture in the skin. Also called sidelighting.

Depth of field. The distance that is sharp beyond and in front of the focus point at a given aperture.

Dragging the shutter. Using a shutter speed slower than the X-sync speed in order to capture the ambient light in a scene.

Feathering. Misdirecting the light deliberately so that the edge of the beam of light illuminates the subject.

Fill card. A white or silver-foil-covered card used to reflect light back into the shadow areas of the subject.

Fill light. Secondary light source used to fill in the shadows created by the main light.

Flash fill. Flash technique that uses electronic flash to fill in the shadows created by the main light source.

Flash main. Flash technique in which the flash becomes the main light source and the ambient light in the scene fills the shadows created by the flash.

Flashmeter. A handheld incident meter that measures both the ambient light of a scene and when connected to the main flash, will read flash only or a combination of flash and ambient light. They are invaluable for determining outdoor flash exposures and lighting ratios.

Full-length portrait. A pose that includes the full figure of the model from head to toe. Full-length portraits can show the subject standing, seated or reclining.

Gobo. Light-blocking card that is supported on a stand or boom and positioned between the light source and subject to selectively block light from portions of the scene.

Gutter. The inside center of a book or album.

Head-and-shoulder axis. Imaginary lines running through shoulders (shoulder axis) and down the ridge of the nose (head axis). The head-and-shoulder axis should never be perpendicular to the line of the lens axis.

High-key lighting. Type of lighting characterized by low lighting ratio and a predominance of light tones.

Highlight. An area of the scene on which direct light is falling, making it brighter than areas not receiving direct light (*i.e.,* shadows).

Histogram. A graph associated with a single image file that indicates the number of pixels that exist for each brightness level. The range of the histogram represents values from 0 to 255, reading left to right, with 0 denoting "absolute" black and 255 denoting "absolute" white.

Incident light meter. A handheld light meter that measures the amount of light falling on its light-sensitive cell.

JPEG (Joint Photographic Experts Group). An image file format with various compression levels. The higher the compression rates, the lower the image quality, when the file is expanded (restored). Although there is a form of JPEG that employs lossless compression, the most commonly used forms of JPEG employ lossy compression algorithms, which discard varying amounts of the original image data in order to reduce file storage size.

Kicker. A backlight (a light coming from behind the subject) that highlights the hair, side of the face or contour of the body.

Lead-in line. In compositions, a pleasing line in the scene that leads the viewer's eye toward the main subject.

Lighting ratio. The difference in intensity between the highlight side of the face and the shadow side of the face. A 3:1 ratio implies that the highlight side is three times brighter than the shadow side of the face.

Loop lighting. A portrait lighting pattern characterized by a loop-like shadow on the shadow side of the subject's face. Differs from paramount or butterfly lighting because the main light is slightly lower and farther to the side of the subject.

Low-key lighting. Type of lighting characterized by a high lighting ratio and strong scene contrast as well as a predominance of dark tones.

Main light. The main light in portraiture used to establish the lighting pattern and define the facial features of the subject.

Modeling light. A secondary light mounted in the center of a studio flash head that gives a close approximation of the lighting that the flash tube will produce. Usually high intensity, low-heat output quartz bulbs.

Noise. A speckled look, similar to film grain, that happens when stray electronic information affects the image sensor sites. It is made worse by heat and long exposures. Noise shows up more in dark areas making evening and night photography problematic with digital capture.

Overlighting. When the main light is either too close to the subject, or too intense and oversaturates the skin with light, making it impossible to record detail in highlight areas. Corrected by feathering the light or moving it back.

Parabolic reflector. Oval-shaped dish that houses a light and directs its beam outward in an even, controlled manner.

Paramount lighting. One of the basic portrait lighting patterns, characterized by a high main light placed directly in line with the line of the subject's nose. This lighting produces a butterfly-like shadow under the nose. Also called butterfly lighting.

Perspective. The appearance of objects in a scene as determined by their relative distance and position.

PSD. Photoshop file format (PSD) is the default file format and the only format that supports all Photoshop features. The PSD format saves all image layers created within the file.

RAW. A file format, which uses lossless compression algorithms to record picture data as is from the sensor, without applying any in-camera corrections. In order to use images recorded in the RAW format, files must first be processed by compatible software. RAW processing includes

the option to adjust exposure, white balance and the color of the image, all the while leaving the original RAW picture data unchanged.

Reflected light meter. Measures the amount of light reflected from a surface or scene. All in-camera meters are of the reflected type.

Reflector. (1) Same as fill card. (2) A housing on a light that reflects the light outward in a controlled beam.

Rembrandt lighting. Portrait lighting pattern characterized by a triangular highlight on the shadow side of the face.

Rim lighting. Portrait lighting pattern where the main light is behind the subject and illuminates the edge of the subject. Most often used with profile poses.

Rule of thirds. Format for composition that divides the image area into thirds, horizontally and vertically. The intersection of two lines is a dynamic point where the subject should be placed for the most visual impact.

Scrim. A panel used to diffuse sunlight. Scrims can be mounted in panels and set in windows, used on stands or can be suspended in front of a light source to diffuse the light.

Seven-eighths view. Facial pose that shows approximately seven-eighths of the face. Almost a full-face view as seen from the camera.

Shadow. An area of the scene on which no direct light is falling, making it darker than areas receiving direct light, i.e., highlights.

Sharpening. In Photoshop, filters that increase apparent sharpness by increasing the contrast of adjacent pixels within an image.

Short lighting. One of two basic types of portrait lighting in which the main light illuminates the side of the face turned away from the camera.

Slave. A remote triggering device used to fire auxiliary flash units. These may be optical or radio-controlled.

Softbox. A box-shaped light modifier that houses one or more light heads and has a single or double-diffused scrim on the front.

Specular highlights. Small, bright highlights with no detail.

Split lighting. Type of portrait lighting that splits the face into two distinct areas: shadow side and highlight side. The main light is placed far to the side of the subject and slightly higher than the subject's head height.

Spotmeter. A handheld reflected light meter that measures a narrow angle of view, usually 1 to 4 degrees.

Straight flash. The light of an on-camera flash unit that is used without diffusion.

TTL-balanced fill flash. Flash exposure systems that read the flash exposure through the camera lens and adjust flash output to compensate for flash and ambient light exposures, producing a balanced exposure.

Tension. A state of visual imbalance within a photo.

Three-quarter-length pose. Pose that includes all but the lower portion of the subject's body. Can be from above the knees and up, or below the knees and up.

Three-quarter view. Facial pose that allows the camera to see three-quarters of the facial area. Subject's face usually turned 45 degrees away from the lens so that the far ear disappears from camera view.

Umbrella. An umbrella-shaped device used to soften the illumination from a studio light.

Vignette. A semicircular, soft-edged border around the main subject. Vignettes can be either light or dark in tone and can be included at the time of shooting, or added later in printing.

White balance. The camera's ability to correct color and tint when shooting under different lighting conditions including daylight, indoor and fluorescent lighting.

Wraparound lighting. Soft type of light, produced by umbrellas, that wraps around subject producing a low lighting ratio and open, well-illuminated highlight areas.

X-sync. The shutter speed at which focal-plane shutters synchronize with electronic flash.

Zebra. A term used to describe reflectors or umbrellas having alternating reflective materials such as silver and white cloth.

INDEX

PORTRAIT PHOTOGRAPHER'S HANDBOOK, 3rd Ed.

Bill Hurter

A step-by-step guide that easily leads the reader through all phases of portrait photography. This book will be an asset to experienced photographers and beginners alike. $34.95 list, 8.5x11, 128p, 175 color photos, order no. 1844.

GROUP PORTRAIT PHOTOGRAPHY HANDBOOK

2nd Ed.

Bill Hurter

Featuring over 100 images by top photographers, this book offers practical techniques for composing, lighting, and posing group portraits—whether in the studio or on location. $34.95 list, 8.5x11, 128p, 120 color photos, order no. 1740.

RANGEFINDER'S PROFESSIONAL PHOTOGRAPHY

edited by Bill Hurter

Editor Bill Hurter shares over one hundred "recipes" from *Rangefinder's* popular cookbook series, showing you how to shoot, pose, light, and edit fabulous images. $34.95 list, 8.5x11, 128p, 150 color photos, index, order no. 1828.

THE BEST OF WEDDING PHOTOJOURNALISM

Bill Hurter

Learn how top professionals capture these fleeting moments of laughter, tears, and romance. Features images from over twenty renowned wedding photographers. $34.95 list, 8.5x11, 128p, 150 color photos, index, order no. 1774.

THE BEST OF FAMILY PORTRAIT PHOTOGRAPHY

Bill Hurter

Acclaimed photographers reveal the secrets behind their most successful family portraits. Packed with award-winning images and helpful techniques. $34.95 list, 8.5x11, 128p, 150 color photos, index, order no. 1812.

THE PORTRAIT PHOTOGRAPHER'S GUIDE TO POSING

Bill Hurter

Posing can make or break an image. Now you can get the posing tips and techniques that have propelled the finest portrait photographers in the industry to the top. $34.95 list, 8.5x11, 128p, 200 color photos, index, order no. 1779.

THE BEST OF PORTRAIT PHOTOGRAPHY

2nd Ed.

Bill Hurter

View outstanding images from top pros and learn how they create their masterful classic and contemporary portraits. $34.95 list, 8.5x11, 128p, 180 color photos, index, order no. 1854.

SIMPLE LIGHTING TECHNIQUES

FOR PORTRAIT PHOTOGRAPHERS

Bill Hurter

Make complicated lighting setups a thing of the past. In this book, you'll learn how to streamline your lighting for more efficient shoots and more natural-looking portraits. $34.95 list, 8.5x11, 128p, 175 color images, index, order no. 1864.

THE ART OF PREGNANCY PHOTOGRAPHY

Jennifer George

Learn the essential posing, lighting, composition, business, and marketing skills you need to create stunning pregnancy portraits your clientele can't do without! $34.95 list, 8.5x11, 128p, 150 color photos, index, order no. 1855.

JEFF SMITH'S LIGHTING FOR OUTDOOR AND LOCATION PORTRAIT PHOTOGRAPHY

Learn how to use light throughout the day—indoors and out—and make location portraits a highly profitable venture for your studio. $34.95 list, 8.5x11, 128p, 170 color images, index, order no. 1841.

PROFESSIONAL CHILDREN'S PORTRAIT PHOTOGRAPHY

Lou Jacobs Jr.

Fifteen top photographers reveal their most successful techniques—from working with uncooperative kids, to lighting, to marketing your studio. $34.95 list, 8.5x11, 128p, 200 color photos, index, order no. 2001.

MASTER LIGHTING GUIDE
FOR PORTRAIT PHOTOGRAPHERS

Christopher Grey

Efficiently light executive and model portraits, high and low key images, and more. Master traditional lighting styles and use creative modifications that will maximize your results. $29.95 list, 8.5x11, 128p, 300 color photos, index, order no. 1778.

SOFTBOX LIGHTING TECHNIQUES
FOR PROFESSIONAL PHOTOGRAPHERS

Stephen A. Dantzig

Learn to use one of photography's most popular lighting devices to produce soft and flawless effects for portraits, product shots, and more. $34.95 list, 8.5x11, 128p, 260 color images, index, order no. 1839.

POSING FOR PORTRAIT PHOTOGRAPHY
A HEAD-TO-TOE GUIDE

Jeff Smith

Author Jeff Smith teaches surefire techniques for fine-tuning every aspect of the pose for the most flattering results. $34.95 list, 8.5x11, 128p, 150 color photos, index, order no. 1786.

LIGHTING TECHNIQUES FOR LOW KEY PORTRAIT PHOTOGRAPHY

Norman Phillips

Learn to create the dark tones and dramatic lighting that typify this classic portrait style. $34.95 list, 8.5x11, 128p, 100 color photos, index, order no. 1773.

MONTE ZUCKER'S
PORTRAIT PHOTOGRAPHY HANDBOOK

Acclaimed portrait photographer Monte Zucker takes you behind the scenes and shows you how to create a "Monte Portrait." Covers techniques for both studio and location shoots. $34.95 list, 8.5x11, 128p, 200 color photos, index, order no. 1846.

DIGITAL PHOTOGRAPHY FOR CHILDREN'S AND FAMILY PORTRAITURE, 2nd Ed.

Kathleen Hawkins

Learn how staying on top of advances in digital photography can boost your sales and improve your artistry and workflow. $34.95 list, 8.5x11, 128p, 195 color images, index, order no. 1847.

CHILDREN'S PORTRAIT PHOTOGRAPHY
A PHOTOJOURNALISTIC APPROACH

Kevin Newsome

Learn how to capture spirited images that reflect your young subject's unique personality and developmental stage. $34.95 list, 8.5x11, 128p, 150 color images, index, order no. 1843.

PROFESSIONAL PORTRAIT POSING
TECHNIQUES AND IMAGES FROM MASTER PHOTOGRAPHERS

Michelle Perkins

Learn how master photographers pose subjects to create unforgettable images. $34.95 list, 8.5x11, 128p, 175 color images, index, order no. 2002.

SCULPTING WITH LIGHT

Allison Earnest

Learn how to design the lighting effect that will best flatter your subject. Studio and location lighting setups are covered in detail with an assortment of helpful variations provided for each shot. $34.95 list, 8.5x11, 128p, 175 color images, diagrams, index, order no. 1867.

STUDIO PORTRAIT PHOTOGRAPHY OF CHILDREN AND BABIES, 3rd Ed.

Marilyn Sholin

Work with the youngest portrait clients to create cherished images. Includes techniques for working with kids at every developmental stage, from infants to young school-age kids. $34.95 list, 8.5x11, 128p, 140 color photos, order no. 1845.

MARKETING & SELLING TECHNIQUES
FOR DIGITAL PORTRAIT PHOTOGRAPHY

Kathleen Hawkins

Great portraits aren't enough to ensure the success of your business! Learn how to attract clients and boost your sales. $34.95 list, 8.5x11, 128p, 150 color photos, index, order no. 1804.

THE ART OF CHILDREN'S PORTRAIT PHOTOGRAPHY

Tamara Lackey

Learn how to create images that are focused on emotion, relationships, and storytelling. Lackey shows you how to engage children, conduct fun and efficient sessions, and deliver images that parents will cherish. $34.95 list, 8.5x11, 128p, 240 color images, index, order no. 1870.

PROFESSIONAL PORTRAIT LIGHTING
TECHNIQUES AND IMAGES FROM MASTER PHOTOGRAPHERS

Michelle Perkins

Get a behind-the-scenes look at the lighting techniques employed by the world's top portrait photographers. $34.95 list, 8.5x11, 128p, 200 color photos, index, order no. 2000.

AVAILABLE LIGHT
PHOTOGRAPHIC TECHNIQUES FOR USING EXISTING LIGHT SOURCES

Don Marr

Don Marr shows you how to find great light, modify not-so-great light, and harness the beauty of some unusual light sources in this step-by-step book. $34.95 list, 8.5x11, 128p, 135 color images, index, order no. 1885.

JEFF SMITH'S SENIOR PORTRAIT PHOTOGRAPHY HANDBOOK

Improve your images and profitability through better design, market analysis, and business practices. This book charts a clear path to success, ensuring you're maximizing every sale you make. $34.95 list, 8.5x11, 128p, 170 color images, index, order no. 1896.

ON-CAMERA FLASH
TECHNIQUES FOR DIGITAL WEDDING AND PORTRAIT PHOTOGRAPHY

Neil van Niekerk

Discover how you can use on-camera flash to create soft, flawless lighting that flatters your subjects—and doesn't slow you down on location shoots. $34.95 list, 8.5x11, 128p, 190 color images, index, order no. 1888.

PROFESSIONAL DIGITAL TECHNIQUES FOR PHOTOGRAPHING BAR AND BAT MITZVAHS

Stan Turkel

Learn the important shots to get—from the synagogue, to the party, to family portraits—and the symbolism of each phase of the ceremony and celebration. $34.95 list, 8.5x11, 128p, 140 color images, index, order no. 1898.

MOTHER AND CHILD PORTRAITS

Norman Phillips

Learn how to create the right environment for the shoot and carefully select props, backgrounds, and lighting to make your subjects look great—and allow them to interact naturally, revealing the character of their relationship. $34.95 list, 8.5x11, 128p, 225 color images, index, order no. 1899.

500 POSES FOR PHOTOGRAPHING WOMEN

Michelle Perkins

A vast assortment of inspiring images, from head-and-shoulders to full-length portraits, and classic to contemporary styles—perfect for when you need a little shot of inspiration to create a new pose. $34.95 list, 8.5x11, 128p, 500 color images, order no. 1879.

500 POSES FOR PHOTOGRAPHING BRIDES

Michelle Perkins

Filled with images by some of the world's most accomplished wedding photographers, this book can provide the inspiration you need to spice up your posing or refine your techniques. $34.95 list, 8.5x11, 128p, 500 color images, index, order no. 1909.